Iben Mondrup

Justine

OPEN LETTER
LITERARY TRANSLATIONS FROM THE UNIVERSITY OF ROCHESTER

Translated from
the Danish by
Kerri A. Pierce

Copyright © Iben Mondrup & Gyldendal, Copenhagen, 2012
Published by agreement with Gyldendal Group Agency
Translation copyright © by Kerri A. Pierce, 2016
Originally published in Denmark as *En to tre - Justine*

First edition, 2016
All rights reserved

Library of Congress Cataloging-in-Publication Data:

Names: Mondrup, Iben, 1969- author. | Pierce, Kerri A., translator.
Title: Justine / by Iben Mondrup ; translated from the Danish by
 Kerri A. Pierce.
Other titles: En to tre - Justine. English
Description: Rochester, NY : Open Letter, 2016.
Identifiers: LCCN 2016014081| ISBN 9781940953489 (pbk. : alk. paper) |
 ISBN 1940953480 (pbk. : alk. paper)
Subjects: LCSH: Women artists—Denmark—Fiction. | Single women—Fiction. |
 GSAFD: Erotic fiction. | Psychological fiction.
Classification: LCC PT8177.23.O57 E513 2016 | DDC 839.813/8—dc23
LC record available at https://lccn.loc.gov/2016014081

Printed on acid-free paper in the United States of America.

Text set in Dante, a mid-20th-century book typeface designed by Giovanni Mardersteig.
The original type was cut by Charles Malin.

Design by N. J. Furl

Open Letter is the University of Rochester's nonprofit, literary translation press:
Lattimore Hall 411, Box 270082, Rochester, NY 14627

www.openletterbooks.org

Justine

One

An orange spot in the dark. A meteor has fallen. I head that way. Toward the heat. And the house. The flames are orange. They stretch up in the sky red licks the wood burns. My house is burning. People are here. They're standing around the house that's mine, and they're watching it, or are also just now arriving. They shout. They draw, push, urge me forward. I'm standing next to the hedge. The flames leap hop, hop, hophophop from wall to roof to bush. My phone's in my pocket. I can't get it out. I think I've forgotten it's there. No. I have it. And here comes Vita. She has a phone. She's dialing. She says: Hello. She says it. My house is burning. The flames are black, leaping. You can't save it, Vita says, she says: What'll you do? Dry-powder extinguishing. Then the workshop collapses. It groans, cants outward tumbles inward. Settles onto the lawn pumps embers onto my hands. A child screams and cries. Mom screams the child screams for a mom. And there she is. I can see her. In flames. The fire devours a breast and an arm melts down to fat. Bent Launis shouts. They're coming, they're coming. The sirens seethe of wheels. A massive firetruck. A massive firetruck is coming. Firemen spring out, spring over great gaps, pull out the hose, turn on the spigot, pull on their masks, pump water onto the house and onto the workshop. The farmhouse roof squeals, bows, is warped, is coming down. Snaps. Falls. Ends.

First there's a headache and a throat and a person prone on a couch. They belong to the hands, which hurt. It's me. It's me that is me.

I'm sure of that now. A growth on the couch, a cushion-wedged tumor. I've woken up on Vita's couch, still in my clothes.

I reach for something. A bottle maybe. No. A body. I reach for a body. I'm in Vita's house. It's Vita's body I'm reaching for in the light from the window. Morning falls onto my boots. I lean forward to loosen the laces and see that there's mud on the floor. Or vomit. My fingers won't, and the laces snarl.

Now she comes from the bedroom, parts the drapes with her hand, steps in or out. It's not a Dream, it's Reality in a shirt she looks like a young girl who fibs. Or a ghost, the way she blends with the drapes.

"I'm here," I say.

"You're here," she says. "Indeed."

"Indeed."

"You need to sleep."

"I need to wake up."

"You stink."

I've got a uvula in my mouth and a tongue that's swelling. I can barely get Vita down, it's so crowded in there. She's almost transparent with her eyes she's seen my house.

"Let's go down and see it," I say. "I'd like to see it, too."

"It's not going anywhere," she says. "In any case, you should do something about your hands first."

I'd like to go to the bedroom with her. She's probably going to change clothes. Oh, won't you stay with me? Go down to the house with me, won't you? You and me. C'mon.

I head into the hall and look at myself in the mirror. Strange. My head looks too small for my shoulders. Shrunken. My mouth looks like an asshole. Is that really me? Yes. You.

I splash some water on my face. It's so still around my face soaks the liquid up. Vita is somewhere else in the house, I don't know where.

4

"I'm doing it," she says from that place, "Now I'm really leaving."
She evaporates.
Three two one. I think.

Water has scattered the pebbles. It flows out of the yard and turns into mud. There are trenches where cars scraped lines in the puddles. Grandpa's gate is gone. I can walk right in. It crunches, I scrape the surface with my foot. Bitter is how it smells. Small is what it's become. Flat under the open sky. In the kitchen, pipes stick out of the earth. The sink hangs counterless. My armoire is gone, yes, gone plain and simple. Grandpa's armchair is just a jumble of springs. Plastic glasses are black clumps. No walls, and the worskshop roof is still on the lawn. The workshop itself, and everything it held, is gone. No walls prop up no works among shards of pots and glass, wood, paper, leather, brushes, sketches, cloth, and there's the nail gun in a mess of rock wool. The neighbor's tin shed has acquired a black façade and a fig bush with the fruit dripping syrup.

Now Bent Launis comes.

"It's just awful. And all your things," he says.

He looks like he's about to . . . no, Bent, don't cry.

"And your grandfather . . . it was one of the society's finest houses," he says.

I see the house as he sees it, an afterimage between us. In the absence of red, it looks green, almost turquoise.

"Of course we'd all like to see the house rebuilt. It was one of our gems. You've got insurance, right?" he says.

"Just stop," I say. "Just stop. Don't you see it's all red and burnt? I've got blisters on my hands—they burned inside, you know."

I hear myself shouting, and I hold my hands out to him. Bent takes them and says:

"Well, for a start let's go and put something cold on them."

He opens the door and pulls me inside.

"Sit down there," he says and wraps, wraps, wraps, and cools.

"What were you just talking about?" he asks. "What did you say? There wasn't anyone in the house? Oh hell, there wasn't anyone, was there, Justine?"

"No, no, no," I say. "Who said that?"

"Well, you did."

And then he wraps some more and nods.

A very young policeman takes down the report about the fire and the house. It's all minutiae. He's only asking the standard questions, he says, and then he explains the investigative process. It's important, he says, to find the cause of the fire so that they can rule out criminal activity. Generally, though, that's just important for the insurance, he tells me, and asks do I understand? Yes, I understand. Am I insured? I am. Who owned the house? I did. Where was I when the fire started?

I sit on my side of the table and look at him and wonder if he knows it was Grandpa's house that burned. How would he know that? He definitely doesn't know that I have an exhibition in September, and that the artworks I was going to show were in that house, packed away in the plastic and cardboard that burned so beautifully. Actually, I was just waiting for the movers to come and pick everything up.

"I was at the pub and came home and saw it burning," I say.

I wasn't there celebrating, there hasn't been anything to celebrate in a while, Vita doesn't want to be with me anymore, and so I left. I just left, it's been a while, a couple of weeks at least. Or was it just the other day? Last night? What's happening? She was right there, now she's not, and anyway, I think she was there this morning.

I watch the officer, he's so blue. He watches the paper and the pen as it wanders the spaces. He flips the page over and continues writing on yet another clean surface.

Vita didn't want to go to Iceland with me. She didn't want to go anywhere with me, she said. Why should she? Hey you, it's over. Now she's sitting at home and waiting.

The policeman has finished writing, there are no more questions. He says:

"Well, that's it then. Goodbye."

She's not here.

And every last bit is burned. I try to remember whether I locked the door before leaving. Why should I? I never do. Anyone could've waltzed in and poured out a gas can and set it ablaze. She could've grabbed a bottle of alcohol of the shelf, and then voilà: fire. But who the hell would come up with that idea? Am I losing it?

I feel something in my pocket that sends a tingle through my gut, a key. No. Two of them.

Vita still isn't home.

Jens and Lisbeth and Peppe are sitting beneath the flagpole in the Society's park. They've raised a T-shirt that's currently flying half-furled and they call:

"Justine. Hey girl. What happened to your place? Grab a beer, tell us all about it."

I grab a beer from the cooler on which Peppe sits. They've figured out how it's all connected, they've just been discussing it, Peppe says. They're certain someone's after me, and I'm pretty certain of it, too. That's what I say somehow or other.

"You can always come down here," Lisbeth says. "I remember your grandfather well."

Her legs are swollen, taut and glossy with a bluish tinge.

Peppe cuts in. He says that he also remembers Grandpa. Actually, he owes Grandpa a favor. I can stay with him and Jens.

They haven't seen Vita. They don't notice when I leave either.

B eneath a piece of particle board at the fire site is the door to the small earthen cellar. There's still a package of butter, a chunk of cheese, and an open milk. I wander around and try to comprehend it, find a banana-shaped sneaker, sink down under the apple tree, puke. Never again will I hear Grandpa growl his irritability about this, that, or the other, snap at him, apologize and sympathize and move on.

I inherited his burned house. He wanted it that way.

"It's mine," he said. "Hell, I built it. And now it's yours. Basta. And yeah, yeah, yeah, I know that it's worth millions out here, but you just go on and try to sell it, my girl. You just dare to."

He died and it still isn't right. Not on the inside.

Grandpa built the house for Grandma. They had a little apartment in the city and needed some fresh air. All the Amager Allotment Society had was a tool shed. Grandpa worked the earth. Good, slow vegetables, he said. Healthy. And free.

He got the land right before the war, but he only built the house after the war was over. A wooden house. Forty square meters. With mullion windows and a blue door. Ample, he said, big enough. When Grandma died, he moved out there, and after he had emptied the house, he converted the place to a studio. All the furniture and miscellany disappeared. Paintings and siccative and French turpentine moved in.

I did the extension myself. After he died. Now he's died all over again. The extension became a workshop, which ate up a good

part of the garden, though he would've been fine with that. He would've had a good laugh if he'd known just how much being insured meant. After all, it's just clean air and a good idea some suit dreamed up, just a swindle, what a humbug, he'd say. You're responsible for what's yours. Why invest in misfortune? No. You've got to be careful with fire, that confounded woodeater.

I know it. A bitter experience dripping with syrup. If the house burns, you can always build a new one, right, Grandpa? It's not the easiest thing in the world, and certainly not the cheapest, but in any case you can get it done. That's how you'd look at it. "Don't come here blabbing about money," you would've said. You'd do it yourself for nothing, your muscles all supple, just nail some boards and go to town on the rest, and saw, hammer.

She's such an ass. No. Not an ass. She's the hole. The asshole. No, that's way too kind. A shit. The shit that comes from the asshole, that's her. Schluck, she hits the floor, splat, and, god, what a stench.

Maybe she's back now? She's obviously been at work in the herb garden. There are the tools leaned up against the side of the house. The straw hat hangs provocatively on the pitchfork and wants to lift off in the breeze, but it's still here. Vita really is no place at all.

She lives in the Society's sole brick house and that amuses her. To be suburban amid sub-urbanites.

I piss on the potatoes outside the bedroom window. That'll make them stink.

She hasn't put the extra key back in its usual place beneath the pot on the steps. I'll check again. Nope. She'd already removed the key the day after we quit. She said that's what happens when someone splits up. What a shitty thing to say.

"We're not splitting up," I said. "When you split up, it's much more official."

At that point she took the key.

"Is that official enough for you?" she asked.

One might've expected her to make an exception in this type of situation. Nope. Her key is still in my pocket, and there's also one to Ane's studio. They jingle.

I look through the kitchen window at a box on the kitchen counter. Green tops stick out. It's Thursday and she's obviously not

been digging in the garden. Today she's at the studio minding the sensitive casting process, as she calls it. Anything can go wrong at this point. Vita is a sculptor. With a large sculpture at the Kastrup Airport outside terminal three. She entices everyone. She rolls out distance like a carpet that can't be stepped on.

A ne doesn't answer. I let it ring a time or two. She said that I should just let it ring. If that doesn't work, I should call again, because now that she's nursing she can't always reach the phone. She sets it down in various places. That's mommy brain for you, she says. C'mon. Pick up. Now she's picking up. Nope. That was just the answering machine. Now she's picking up.

She's spent the day with the baby, who got through an entire feeding without any problems, she says. Now he's down for a nap. I tell her I'm in the city nearby. I don't mention the fire.

At the door she already notices my hands.

"Oh no," she says. "You've burned yourself."

She's been waiting for tragedy to rain down like fire, and now it's happened.

"I can't help it," she says. "All I really want is for you to have a chance at a normal life. Why did something like this happen to you? Honestly, Justine. Can it get any worse?"

Now we're in the kitchen of her apartment. The baby is awake and on its stomach across her arm, she rocks it soundly up and down.

"I just don't get it," she says. "It's just too disturbing. Let me see your hands. They're completely burned. Who wrapped them? Don't you think you should have someone look at them?"

It's not all that bad. In some ways, it's actually quite wonderful that my hands hurt.

"Could someone have done it on purpose?" she asks.

The baby closes his eyes. I shouldn't have come here. I knew that beforehand, and now Ane tells me that Torben is on his way home. He had a gallery meeting.

"I mean it," she says. "You can stay at The Factory for a couple of days until you find some other place. There's a kitchen in the hall where you can cook."

"Star-crossed love is a costly thing," I say. "She disappears, before long she's completely white."

"That's a strange thing to say. Why did you say that? Did something happen with Vita?" she asks, putting a hand to my cheek.

I'm not a little child. Take that hand away, no, leave it there.

Ane disappears into the bedroom with the baby. She peppers me with questions while I sit in the kitchen waiting on answers, on her, on an exit.

"Thanks for not asking if you can live here," she says, handing me a sleeping bag.

It's Torben's.

"You can have it. He won't need it anymore. After all, he's a father now."

Two

The Factory is enormous. Its roof resembles a toppled Toblerone piece. I've been here before. And this is the first time. That doesn't sound quite right, but that's how it is. I'm the selfsame who's different now.

Here mid-break there's no one, or hardly anyone, around. Light streams into the expansive hall through skylights high overhead. On the floor is something that might have been a wooden sculpture, now sawed to pieces. The chainsaw is still plugged in. Crates and pallets are scattered around, angular islands in the large space.

Ane occupies a long hallway with studios to either side. Here it is. She's propped her works against the wall with the backs out so they're not in the way. All the paintings and drawings that she's still working on. Empty spots along the wall show where the paintings were hung, and long runnels of paint merge together on the floor.

The idea was for her to escape the baby when the time came, so that she could get some work done. The time never came, the baby cried and had an upset stomach. He always had to be on her arm. Torben didn't want to hear her say it was colic. Recently, he looked at me and said: "Well hell, all babies cry."

She's prepared the space for me. The broom is against the wall in front of a pile on the floor. The table has been cleared and there's a mattress leaning against a file cabinet. I unroll Torben's sleeping bag. What a smell, I can't sleep in that. I try the mattress out in the middle of the room and also next to the door. It's best beside the wall, I think. From here I can survey the whole future. It casts itself

rather unsteadily down to the corner store with beer thoughts that make my teeth water.

The Factory is still deserted. I'm a small body in a large building. My hands are unwrapped now. I thought it was worse. These are just beer-filled blisters.

I light a candle and lie down. Now I'm lying and falling, touching upon dream, reality, dream, reality. What's the difference? It's dark. Am I asleep?

There's Grandpa's house in flames again anyway. And here I come dancing along the rooftop, devouring red wood, licking the paint off with a bubbling tongue, window panes shatter. And now I hear it. Yes. It's really there. An itty bitty voice. I press my ear to the wall. It's just the flames' crackling, rather like suppressed laughter. Justi-hi-hi-hi-hi. Ouch. It's growing hot. It bites my flesh, I turn and run and run and of course don't get anywhere. So, it's a dream then.

Now I wake with my eyes. Light. Am I really awake? Oh; one of the candles has tipped over next to my head. Is it burning? The flame plays with paper sucks in wax, Torben's sleeping bag crackles. Holding the pillow before my face, I slap at the flames with a cushion. Black becomes gray, and now it's turning blue outside.

Behind a wooden board in the hall are several large photographs. A girl I don't know well, her name is Helene, has taken some self-portraits. She's a painter. In these pictures, though, she's obviously the photographer. Anyway, she's the one in front of the mirror. She's in her underwear. One hand holds out the camera that's taking the pictures. The flash is a white sun burning a hole through her body. She's unconcerned, her face beams. There are quite a few photos, a whole series of them, and in each one Helene is thinner. The bright eyes disappear in picture No. 7. She's standing in front of the mirror and looking at herself in obvious disbelief. In No. 12 and No. 13 she's holding a piece of paper with a date on it. No. 14 was taken on May 4, 1998. Here a sallow-skinned Helene leans against the wall inspecting a rump that's no longer a rump. Then comes the last picture, which was taken nearly six months later. Here Helene is different. She's in the same pose on skinny legs beneath an enormous body that hangs over the waistband of her panties like over-risen dough. She's smiling. A terrible smile. That smile gives me a bad feeling inside.

I let go; the pictures smack against the wall. That smile's a state on the brink.

And horribly, it reminds me of something else, Eske from the academy of arts, the guy with the depressed dad. His dad isn't all there, he calls Eske at home and leaves messages on his answering machine. Every single day. When the answering machine picks up, he describes how he'll take his own life. He's come up with any

number of ways to do it. He'll hang himself from a tree. He'll eat caustic soda. He'll go straight out into the water and drown himself. Farewell.

Eske had an exhibit for a time with a white box you could crawl into. When you were all the way inside, you could press play on the answering machine and listen to his father's messages. "I'm going to do it. I'm really going to do it . . ."

I've been in that white space.

"I'll do it soon. I'll take my belt. The narrow leather one. I'll fix it right up for you all."

Ane and her paintings fill the space. My person is broken down to small fragments, flitting around, colliding with everything that isn't me, but rather her, and coalescing into a body. Finger. Print. That's always the gist of us, right?

One of Ane's paintings is a paisley landscape without up and down, near and far, or horizon. She's made a rip in which the colors blend in spirals inside the brain's winding coils, and amid a flock reminiscent of thought, an underwater life of seaweed. Fish with bird heads, birds sporting arms, little girls with bare breasts and rough hands, boys without legs, some laughing, some bleeding. Three girls in French braids display their buttocks, spreading their cheeks to show their deep assholes. A boy combs a longhaired cat, and in the midst of it all a dog-ape hybrid is shaving its legs.

I say it now: I think I'm some other. Or how should I put it? I've become some other. That other hasn't become me, though. She didn't exist before the fire. Or did she? She's a new condition. At once definitive and boundless. I have no clue where we're off to now.

To the bathroom, where all is gray, and I inspect her in the mirror. She looks like me. She holds the large scissors in her hand lifts a hunk of hair. It's my fingers that are chopping, my hair's a hunk that falls. I've kept my hair this long always it's lived a slow life together with me headed down toward the ground, ready to take root below. I cut again, graying the water, I keep cutting until I've come full-circle. The exact same woman in the mirror has an uneven pageboy. We're different. And now what we want is to fuck, not cut. The place is deserted.

He approaches from the front, a young man, well, a big boy really, with a smile on his open face. He approaches me and angles his head back so he won't get cigarette smoke in his eyes. Then he places the hot water kettle and cups on the table and extends his hand through the barrier of air. With a squeeze he says:

"Bo."

Now he removes the cigarette from his mouth. His hair springs in large curls away from his head. He's sunburnt with eyes that are white in the white.

"You're the one who made that video of the woman doing the drum dance, right?" he asks.

He rummages about, not just with his hand, but with his whole arm, no, with his whole body in my space.

"I don't think so. I'm some other."

"Some other? How can you be some other? Other than who?"

"Than myself."

"I'm pretty sure it was you, and . . ."

"I don't think so."

At this point, I've turned around and left, because he can't help it, after all, he's just that open, pure and simple. But he's unconcerned and on my heels, I can hear him, now he's reached the door, he collides with it, uses a hip to push it open and enters the workshop balancing two cups, "coffee," he says. His voice is so wry and he's asked for it now.

"Do you live out here?" he asks.

The coffee makes a thin stripe down his hand and there's a nimbus around him. Youth, I think, and inhale, a distinctive odor, sharp and dry.

"I do, too."

He takes a chair, places his arms on the rests, brown and hairy, and asks if he can smoke. Apparently, it doesn't faze him when I say no; the hair surges from his armpits like crimped fur.

"Wasn't it you in that video? But you don't want to talk about it, right?"

Now he stands up. Is he leaving already? No. He begins to flip the paintings.

"Stop that," I say.

Now he's leaving. No. He's giving me a wry look. Like he thinks he's got me figured out. Let him think that. I can tell he assumes things with me are off-kilter.

Now he's leaving. He draws a current of air behind, sharp and dry.

You'd almost think nothing had happened. Kluden is right where it's always been and Kelly is behind the bar. She's working the night shift, just like the night before.

She opens a beer as soon as I walk in, sets it down in front of me, and pronounces a name that could be mine, I recognize it in any case.

"Well now," Per Olsvig says, "you again?"

He's sitting at the end of the bar.

"He hasn't gone home," Kelly says.

"Sure I have," Olsvig says. "I went to my fucking job."

It's the same conversation about paid work, which is a necessity, even if you're an artist. In a moment he'll tell us everything he can't recall saying before. That's memory slinging for you. They land on Kluden's linoleum floor, back in the corners and beneath the bar stools, where they stick.

"I was doing my thing at the grocery store," Olsvig says. "See, that's honest work with honest people. None of that pretentious piss you all go around and do."

Olsvig drains a shot and orders another on tab. He's so gray. No. Now he shifts slightly and the light from the lamp over the bar falls red onto his face. In a moment I'll buy him a beer. I feel like I've missed him, even though he's so crass. There's an open place right beside him.

"Do I know you?" he asks. "Nah, I'm just ribbing you, Justine, come here and sit next to me."

We know each other as well as the song pumping through the room: "Stairway to Heaven." The sound is like the smoke was massive. Searing. His hooded jersey is thick with grime and old paint, but I can't detect an odor, and my head rests comfortably on his shoulder. He sucks heavily on his cigarette, then stubs the rest into the ashtray, taps the rhythm with his finger on the counter. The door opens, we don't see who comes in, if they know us, it'll happen. Olsvig lights a new cigarette.

"Ahh," he says, "what a day."

The beer is cold and curative. Right now I need Kelly, Olsvig, and "a Tuborg Gold," I say, "no, two!"

He kisses my forehead. Now I want his short arms around me.

"Forty-two," Kelly says.

"Put in on my tab," Olsvig says.

His cheeks are lightly swollen with scattered stubble. I couldn't care less, I want to be inside his body, behind the bluster and gestures, back behind it all, away.

Somehow Per Olsvig just couldn't help it. He graduated from the academy of arts about a year ago, and before that he was already selling his paintings. I was actually there the night it began. Olsvig owed a gallery owner some money, and instead of taking his money, the gallery owner told him he could display a couple of paintings and see whether or not they sold. Before half a day was gone, the gallery sold the first one and the second one shortly thereafter. The owner was beside himself. A mass of drinks were had at Kluden. He wanted everything in Olsvig's studio, all that came from Olsvig's fingers was pure gold, at least for a while. Until it stopped.

Bo left a coffee cup and a stain. Vita notices of course. She notices everything, but acts like it's nothing. Right there, that's where she entered. Wait, didn't she just wander in through the wall?

"Why didn't you use the door?" I ask.

Obviously, she's not going to answer. She'd rather talk about something else. That's unusual. She wants to talk about "sex . . . you know exactly what I mean," she says. "You head to the sack as soon as you meet someone. Do you even think about anything else?"

"What do you mean by sex? He was just sweet," I say. "I didn't do anything. Where's all this coming from?"

"Who isn't sweet?" she asks. "Who isn't sweet and lovely in your eyes? Who isn't so unbelievably wonderful that you just can't help ripping their clothes off? And you know exactly what I mean."

"That's the way people meet," I say. "To claim otherwise is wrong. First there's sex, the naked and the raw. And everything else comes after that. Besides, he knows he's sexy."

"Oh right, you're so smart. So in touch with yourself," she says.

"Could be. But do you really have to spit like that?"

"Hey, I thought you liked secretions."

"I don't get you."

"Obviously, he knows he's sexy," she says. "He has you right where he wants you. As usual, you think you're in complete control. But you don't control anything. You're so transparent. So is he, of course. I give it two days before you're swapping spit."

"Nothing happens. Sometimes it just up and happens," I say.

"Don't go thinking that you're the only person capable of being attracted to someone else. Actually, we're all capable. But that doesn't mean that we just run around and do it with anyone. We stop ourselves before it comes to sex."

She walks through the wall.

"That's pretty smart," she says, looking down at herself.

"Smart."

Three

Ane came all the way out here while I snoozed, right through the door, no slipping through the wall like Vita. Her timing isn't the best, I was in the middle of a party at some other allotment society, Våren, I think it was. Bo was also there, in shorts. His legs stuck out the bottom with crinkly hair and large, well-trimmed hooves. He was confiding something and was leaning over me with his entire weight when Ane came bursting in with the baby in a sling on her chest.

"How wild, Justine. You got a haircut. It looks wild. Why did you do it?"

I shake my hair.

"Well, it's weird. But somehow it fits you." She unfastens the child and puts him in the stroller. "I just came by to see if you had enough room." Her gaze sweeps the space, moving from paintings to work table. "You can stay here as long as you want." In one smooth motion she's at the table, rummage, rummage. "So, is there anything new on the fire?" She flips papers, takes something out, covers it up, rolls it all together.

"Do you need the studio?" I ask.

"No, not at all. I've already told you that."

She gives me a look that implies both consideration and vexation. "How are you doing?"

She turns her back to me and tries stuffing the roll into a cardboard tube, but it's too loose and bursts apart.

I make for the elsewhere of the kitchen and wait a bit before returning.

She's finished packing. The baby is awake and the pacifier slides wetly in and out of his mouth.

"I finally got him to take it. Did you see?"

She bends aside so I can see the baby's face.

"It's funny," she says. "It really does seem to help a bit."

Now it's choking him. She pulls on the pacifier to persuade him to take it again, but he refuses. So she steps over the mattress, takes a seat at the table, and starts liberating her breasts.

"There's been a lot of turnover out here lately," she says.

The boy's big irises scream: Help. With a hand she supports his head and forces it onto her breast. He has no choice but to accept the nipple that's swollen and pearled white. The boy coughs and milk streams out.

"But you're next to Trine Markhøj. You know Trine pretty well, right?"

Burp. Ane holds the baby out from her, milk splatters the floor.

"Take him," she says.

She tucks her breasts back into place. The boy's a disaster, a baby elephant that's shat itself.

"It wasn't your fault," I say.

He goes back in the carriage and Ane starts rocking.

"You have to do it with some force. That makes him fall asleep faster," she says.

Back and forth, back and forth, she doesn't take up much space without the kid. Her gaze makes a final sweep and lands on me.

"I should go."

Good.

When did the whole thing with Ane and Torben start? Let's see, it was probably back during the Berlin trip with Ole Willum, a teacher at the academy of arts. We were staying in the academy's apartment on the attic floor of a large estate out by the Spree. The gable fronting the water had two large glass doors, but the balcony itself was missing, all that remained of it were the iron fittings to which it was once attached.

Torben leaned carefully out and groaned. He was afraid of heights, he said, and didn't want to get too close to the windows. When it came time to choose where we'd sleep, he chose one of the other rooms.

Ole Willum had a show at a small gallery in the city and we were supposed to head out there after unpacking. Torben, a couple of other guys, and Rose, she was always hanging out with the boys, turned up quite a bit later than the rest of us. They were already in high spirits, and were carrying two bags of Weißbier bottles. Ane and I each grabbed a beer and went outside. With a loud laugh, Rose swung her bottle so that it splashed Ane.

"Oh, sorry, little Ane," she said, giggling again and shoving Torben who shoved her back.

Inside the gallery the rest of the students were walking around and experiencing the installation. Willum had created three universes that he'd taken from Björk songs, a red space, a blue one, and a white, each equipped with diverse effects, furniture, and some curtains.

Ane gave Rose a dirty look.

"So, aren't you going in to see the exhibit?" she asked.

Rose didn't hear her, but kept fooling around with Torben and the others.

Willum said our task during the trip was to create a book. The actual content could be whatever we wanted, but the point was to translate an art project onto the books' pages, just like he'd translated Björk's "All Is Full of Love" to the show's white space and her "Come to Me" to the red.

That evening Willum invited two of his friends, an artist couple, to the apartment. The woman, her name was Leise, had done several art books. She showed us her latest, a print series that more or less gave the identical impression of being somewhat dark, somewhat moist, somewhat hairy, somewhat bulbous. The book was entitled *Durch*. Leise explained that the impressions had been taken the moment a baby emerged from its mother's womb. She'd attended twenty-five births, and the instant the baby bubbled forth from between its laboring mother's legs, Leise had pressed the paper to its bloody cranium.

Torben, who was well plied with Weißbier by that time, bent over and inspected the book.

"Does it smell?" he asked.

His nostrils vibrated. Rose snatched the book from his hands and tossed it onto the sofa. He headed for the bathroom and Rose followed.

After Leise and her husband left, Willum and some of the others sat in a circle around a candle on the floor. Outside was blue black. A tall girl lay with her arms hanging out the terrace doors.

Suddenly, someone was shouting: "It's Torben, it's Torben."

Rose pointed out the slanting roof window and we took turns peering out. There on the neighboring roofline a figure was hunched against the sky. It was crawling along the roof's long ridge.

"No fucking way, that can't be Torben," Ole Willum said. "How the hell did he even get up there?"

"He crawled out one of the attic windows," Rose shouted.

She forced her way to the window and opened it.

"Torben! Come back in! Right now! You're going to fucking fall from way up there! You're drunk!"

The shadow that was Torben continued along the roofline until it reached a point directly above a window bay and stretched itself to full Torben height. Abruptly, it slid out and down, landing on the bay. Rose shrieked and raced through the attic to the window out of which Torben had first disappeared, flailing and kicking to get her shoes off, and was on her way out when Willum intervened.

"I'd never actually tell anybody! I'd never do that! I was just talking!" she yelled to Torben.

Torben was slumped against the bay window. People on the floors below were hanging out of their windows, some hollered that they'd call the police if it didn't quiet down. Willum shouted back that it was all under control, just some performance art.

Two hours later Torben was back. Rose had finally persuaded him to crawl in and climb onto the sofa with her. She lay there with a beer. After announcing that he wasn't taking responsibility for someone getting hurt, especially not while they were plastered, Willum went home. Torben sat nodding with a cup of coffee in his hand, and Rose fell asleep on the couch. The others went to bed. Ane and I had planned to sleep on the floor next to the doors facing the river, where it glistened, but Ane wanted to help Torben climb into his sleeping bag first.

The next day Torben was up first, he poured coffee into two vases. Rose was still asleep in her clothes on the couch. Ane wanted to head out immediately. She was going to do something with animals in her book and had bought herself a weekly zoo pass. Before I'd even finished brushing my teeth, she'd left, and she'd taken

her sleeping bag with her. Rose woke up and called for Torben, but he was already gone. He'd taken both his sleeping bag and his backpack.

Rose popped open the last beer and lay back down.

"Fuck, he's not too bright," she said. "He has no idea what he's doing when he's drunk. One time he almost jumped from his work-shop at the school."

"I thought he was afraid of heights," observed the tall girl who hadn't started on her book yet.

"I have no fucking clue what his deal is," Rose said. "But anyway, he can't control himself for shit. Did he say where he was going?"

I packed my bag with a camera, some India ink, and a pad of paper. The only thing that came to mind when I thought of my book's pages were bloody cunts and bloody craniums. That's the exact project that I wanted to create. Unfortunately, my ink was way too blue. I made a mass of doodles, sheer nonsense.

That evening Willum asked how our first day in Berlin went. Rose said that Berlin was boring, and she thought she could work at home as well as here.

"So work here," Willum said.

Rose snorted and lit a cigarette, apparently unconcerned that we'd all agreed to smoke only in the kitchen.

It got dark and still Ane wasn't home. Rose lay on the couch with a cigarette stub hanging from the corner of her mouth. Torben wasn't back either.

"Wake me up when he gets here," Rose said and fell asleep.

On the water the sky sailed past in gleaming patches.

Ane finally turned up on the third day. Torben, too.

"We were in the Tiergarten," she said.

Torben flipped through the pages that would eventually make a book.

"Show them to Justine," Ane said.

Rose, who'd decided her book would just be an ash tray, lit a cigarette and stubbed the previous one out on a piece of paper.

Torben handed me a pile of drawings.

"Assholes," he said.

"And eyes," Ane added.

They were done in pen, hairy, wrinkled, protruding wreaths.

"Gross," Rose said, standing up from the couch and leaving.

Willum flipped through the pages.

"What the hell's wrong with her?" he said. "These are really great. Just stylized assholes."

"And eyes," Ane added.

She collected the sheets and tied a string around them, readying them to be glued and covered.

"Can I see what you did?" she asked.

"I didn't do anything."

"You didn't do anything?"

Of course I did. For instance, I wondered where the hell she might've gone. I'd gone to Tiergarten, and naturally there was no Ane, neither the kiosk woman nor the people standing at the entrance had seen her. It was all a load of crap. Berlin. Willum and his installation, too. And myself. I was also a load of crap.

"Those are some fat assholes," I said, pointing to the elephant's iris.

"We slept in a forest," Ane said.

Torben and Ane stayed in the apartment that night. They put their sleeping pads on the floor beneath the window.

Later that night, after everyone had gone to bed, an extremely drunk Rose appeared. She kicked the kitchen chairs and shouted at Torben.

"What do you want?" Ane asked. "Can't you just leave him alone?"

"What the fuck do you know about it, little Ane? Why are you getting involved anyway?"

"Well, I know he doesn't want to be with you."

"He doesn't want to be with you either, you idiot. You insane little idiot. Sweet, stupid little Ane with all her sweet little stories. If you think he wants to be with you, you're completely fucking wrong. You don't know shit about him, do you? No, why should you? One woman's not enough for him, capiche? He can't keep his dick in his pants. Not that he goes around bragging about it. At least he's smart enough for that. And that's a whole lot smarter than you are."

"Yeah. Well, and you, too," Ane said, vanishing into the attic and slamming the door.

On Friday we set out our books on the floor and went through them. In terms of melancholy, Rose's book was the best, and Willum admitted it was good, even though he thought it'd been an arrogant way to complete the assignment. Willum was also extremely pleased with Ane and Torben's book. You just couldn't tell, he said, if it was an eye or an asshole staring you down.

Torben is big. His body, his mouth, all of it. He majored in graphic design with a group of guys who sought, sought, sought toward the extremes. It has to be about men, they said, and established an artist group.

Their first show featured some paintings they'd schlepped to a barracks out in Slagelse. Once there they'd laid them in a pasture so a private could drive over them with a tank.

The exhibit was held in Kolding. At the opening, they sat in the gallery around a card table playing poker, drinking whiskey, and smoking cigars. Torben got so drunk that he shit his pants. In the wee hours of the morning he traipsed around the city wrapped in a

T-shirt with shit running down his legs. The rumor made it around the whole school, but Ane, of course, didn't believe a word.

After that it was exclusively about pushing limits. At one point the group ingested everything it could get its hands on, everything that could be introduced into the human body with reasonable ease.

One guy got addicted to some particularly hard stuff, and eventually he was thrown out of the academy for putting the fancy chairs in the banquet hall up for sale on eBay. After he left, the other guys started shooting at themselves with various implements or cutting themselves. Or they had the others cut them while they taped it on video.

Ane could watch an entire self-torture video to end without blinking, and there was one episode she found especially appealing. It featured Torben sticking a nail in his hand. He did it over and over again, even after he'd made a large, bloody hole.

"I don't know why," she said. "I can't seem to get it out of my head."

She considered switching to graphic arts, since she thought it would be fun to be a girl surrounded by that sort of guy. I asked:

"What sort of guy?"

"Uncompromising," she said. "Wild."

However, then she attended one of the department's get-togethers and the professor didn't so much as acknowledge her presence. There were other new students that he questioned about this and that, including their interest in graphics.

One of the other aspirants had brought along some photographs that he'd taken the liberty of hanging around the room before everyone arrived. The pictures were taken one night when, returning from the city drunk, he'd danced around his bedroom before the camera in a pair of ridiculous underpants. The guy was chubby and pale, anything but a Chippendale, and the harsh flash only

made a hapless situation worse. Despite the fact that there were some really raw pictures, and much was said about loneliness, self-exposure, and sex, the professor failed to see the quality in them. The guy, who was as deft at clarifying his work as he was at being his work, couldn't make any headway. It was unbearable, Ane thought.

At first Torben wasn't particularly interested in Ane, who bustled around in her rather overlarge smock and talked shop. However, his indifference, which persisted even after our Berlin trip, actually attracted her. He didn't want to tie himself down, she said, and you know, she liked that. It was only following the Christmas party during our second year that she seriously managed to pin him down.

Some girls from one of the painting departments had transformed the party's setting into a three-dimensional work of art. Cheeses hung against a black wall like pock-marked planets. Torben got extremely drunk after bragging that he could down a flask of schnapps in less than half an hour. In the middle of an anthem he fell off the table and split his chin.

Later he tried kicking out the DJ because he thought she was playing shit music, but before he could accomplish the task, a pair of the DJ's friends came along and threw him out instead. They dragged him out the door and down to the plaza and only let him go when they'd gotten quite far away from the party. When he made his way back to the academy, Ane was there to collect him. She found him in the courtyard and put him in a taxi and and took him back to her place. Right after that he moved in with her.

He's wanted to pulverize her from the beginning, to move in and force her out. I'm not just imagining it. Perhaps he doesn't even know it. But I'm certain. Eventually, it'll become clear. He's together with her so that in some insidious way he can squeeze her life out.

Four

Now. Vita's towering up. She's standing tall and white. From below, her face looks like two nostrils and a chin, and her breasts are two sacs with raspberry nipples, ripe for the plucking, they almost tumble into your hand, plop. They're visible because her stomach is flat, her tuft of hair smooth. Vita stands directly over my head with legs spread and opens her mouth, dribbles silence.

If she could just relax a little. If she could just relax, she'd see it. Vita still has something we can share, but she tramps around my face and shoves all else aside, everything that I should reasonably be thinking about, everything that needs to be done, works that never even existed as ideas yet. Every time I think of something concrete, my thoughts stall, and there she is again. Her body. Her leg hair. She has goose bumps. She wants to be bitten on the thigh. She says: Bite hard, that's what I want.

Topple her to the floor, screw her and her head on the floor, screw her hard, spread that flesh, woman, find that finger, rub oblivion into the juicy wound, suck, soothe.

Vita. I know what she means. No use in pretending otherwise. Take, for example, what can I say, take . . . that day at the Louisiana Museum of Modern Art. Vita and I took part in a big exhibit there that featured art from all over Scandinavia. She'd been looking forward to the evening, the lawns, the view over the water, stemmed glasses, and distinguished words about what makes art space a community. It was very evocative and solemn.

We knew most of the guests, so there were plenty of people to talk to and plenty to talk about. Vita had a sculpture out on the lawn reminiscent of a steel top tipped over. We watched out the glass corridor and saw how people couldn't help but stop and touch the gleaming metal. Important individuals came by, we chatted with them, had our glasses refilled, and toasted almost light-heartedly. It'd been a while since Vita had wanted to go anywhere with me, but since the exhibition was at Louisiana, and since we were both showing pieces, she thought the night might attain a certain level of class.

"It's going good with me," she said, and that was good.

I made a point of talking to Lars Henningsen and his wife. Henningsen had been a professor at the academy when Vita was there, and now he sat on one of the major foundations that purchased art. She'd been one of his best students, he confided in me while Vita pretended not to hear. The purchasing committee was going to come and see the exhibit again later that month, they were looking for a sculpture, preferably a large one.

"He has the lifelong grant," Vita said after Henningsen and his wife had gone. "But I don't think he does anything anymore. He's almost blind."

"Do you think he'll buy your top?" I asked.

"Obviously," Vita said.

"Well, couldn't he also decide to buy my work? Does he know who I am?"

"Who?"

My contribution to the exhibit was a self-made video, a Greenlandic drum dance and some singing, five intense minutes of it. I installed the video in a white room together with three tubs of fish, and it was, for all intents and purposes, impossible to watch the whole video without feeling sick.

"Did you plan on selling the work?" Vita asked.

"I don't care about money."

"Then what do you want with Lars Henningsen?"

"I was just curious if he knew who I was."

"Next time I'll introduce you," Vita said, no doubt certain by that point that there wouldn't be a next time.

She was good at talking to people when it suited her, and that night it suited her. Wine flowed into our stemmed glasses and from there into us. Vita fell into conversation with a female sculptor who lived out on Malmö. They knew each other from the Department of Sculpture at the Academy of Arts and talked in a way that was light rather than deep, with emphasis placed on the known and the forgotten. Well, I forgot Vita and grew ebullient. It was the wine combined with the nice weather. Vita talked to an art critic who wanted to write something about her decorations, a whole square out in front of the black monolith-shaped financial center that she was in the process of designing.

I circulated and saw that my video was impacting the senses. The evening wore on, people were leaving. By that point I'd joined

a cluster of people who were all complaining about the same thing, and Vita's brows had acquired their furrow, perhaps because she knew I had no immediate plans to leave. Then I suggested that we go.

"Are you sure you want to?" she asked.

"Yes, yes, come on," I said and headed toward the exit.

And there stood the rest of the group. One of them, Johannes, was a wild-eyed, good-looking Swedish guy I'd talked to earlier. The group bemoaned us leaving, they wanted us to head into the city with them. Vita was like a person who'd expected to conquer a mountain, only to be confronted by yet another peak, and so she climbed into a taxi.

I sent Vita away with Johannes's eyes burning a hole in my neck, and it didn't take too many negotiations before we were standing in a gateway. He took me with huge, scallop-shaped hands, pressed my flesh, marked my skin, supported me with his stalk, and pumped so hard my head grated the rough wall. He came in cascades, filled me with his tenderness, made canine sounds. Afterward, his soft parts withdrew and he became gentle. The eyes, the look, the beast with the gash of a mouth and saliva beneath the chin, he made me want to howl.

"I'm not sure I completely understand all that with the fish," Johannes said later when we were sitting at the bar. "But who gives a fuck. The film is awesome."

"Do you want to know? Do you really want to know?" I mumbled.

"Of course I do, man. Tell me."

"They stink. That's why they're there."

Johannes was an artist from the academy of arts in Stockholm, but he didn't understand what I meant.

"Doesn't matter," I said.

Maybe the fish weren't such a good idea after all. Maybe they were actually there in Vita's honor. They were glossier than steel,

they were far steelier than steel. I could tell that she hated them, even if she didn't say it. I had Johannes's full attention. Until I became too drunk to talk and took a taxi home to Sønderhaven.

When I returned home like that at night or early in the morning, she was a coldness, a distance. Her body said: Tell me, woman, what actual power do you think you have over me? Her work occupied more time than it usually did, even though she didn't have any particular projects she was supposed to be finishing. She took off to Jutland for the weekend without telling me, maybe she had a friend with her, maybe a colleague. They were going to see a burial mound, she said when I asked. I pictured her walking beneath the winter sky with a red nose and mittens together with Harriet, another sculptor, who'd also developed a sudden interest in antiquity's monuments.

All I could do was lay there at home alone and think about things, twist and turn them, look at them from various angles. I was certain she knew everything. Or did she? Vita said nothing. She was just distracted and distant, if not downright departed.

One time she called me from the central station and asked if I wanted to travel with her to Odense. She was going to an opening at a sculpture park where some of her sculptor friends had fashioned two new bridges, but the trains had been delayed, and then it occurred to her that maybe I'd like to come too. I only needed to pack a couple pairs of underwear and some clothes, she said, and we'd stay at a hotel. Some clothes, some underwear, and some water from the kiosk. No word about that which also has a name: infidelity. Ooh. Ahh. I'll fuck you up. How could you do that? You'll

fuck me up. I don't ever want to see you again until I actually want to see you again.

I attempted an excuse. I said:

"I've thought about it . . . that thing that weekend . . . it meant . . ."

I thought of something Ane had said, that I acted like an animal, a filthy, ass-sniffing male dog. Vita put up that expression: Just tell me, bitch . . .

There was nothing to talk about.

I love her. I already loved her that New Year's Eve when the light had long since departed, everyone had gone home, it was only us tough dogs left.

We dragged the old Christmas trees to the fire pit to celebrate, and oh, what a party. It took an entire can of kerosene to start it, but then the fire took hold. The needles sputtered and rose aloft, and suddenly there was Vita holding a bag against the flames. I shouted for her to come away from there, my voice was rather shrill, more so than I would've thought. It was the sight, she was so beautiful, like electricity. Sparks leaped off her hair and forehead as she stepped away from the flames, and stars and needles burned an image in my mind.

Vita had a workshop in Valby, I knew, and one day I sniffed my way there. It was late on one of the afternoons that Valby's galleries hold their openings. I found the address on a side road with pitted asphalt, and a bell next to the gate. After a while Vita emerged from a flat building. She was wearing a shirt and overalls.

"Did you get lost?" she asked.

"I don't think so," I said.

"Which opening are you looking for?"

"I don't actually know," I said and giggled.

The little hall was tidy. Light streamed through a series of small windows set high up. There was a compressor in the middle of the floor, and some tarpaulin covered sculptures farther back.

"Now that you're here, you might as well see them," Vita said and began removing the tarpaulin from one: a white cylinder like a medium-sized wading pool, about a meter or so high. The cylinder's circular surface was bowled, and to one side of the depression was a sphere: an over-dimensional pea paused on its rolling trajectory to the plate's bottom.

"I've never seen that one before," I said.

"Well, it's only been shown once."

"Now I see it."

I circled the sculpture.

"It's quivering," I said.

"That's because the depression is cut asymmetrically, so it appears to be sliding. Let me show you the other," she said and withdrew the tarpaulin from the other sculpture, this one light yellow.

The bowl on this cylinder's surface was bubbled, the surface tension of a water droplet right before it bursts.

"I see a boob," I said.

"I think I'm about to finalize an agreement to place both," she said.

We went out into the winter garden behind the workshop. Here there was a bronze drop. There was also a bench. Vita's energies swirled around the glass conservatory, they flowed from her in tingling streams. Her strong, clean hands, the pale nape beneath her hair, the way she avoided touching me, reached for a watering can, dusted the sand off her hands. We sat side by side. The ease of her movements and the weight of her gaze.

I thought that now I nearly had her, and yet I didn't have her at all, but sat blanching instead in my workshop. I began to bike the opposite of my normal route, but I never saw her. She works a ton, I thought. Finally, I called her and asked if she wanted to go out, I don't know, somewhere or other. Vita didn't have a lot of spare time. She was so smooth.

One day when I saw that her windows were lit and was certain she was home, I simply went back with a bottle of wine. She opened up and . . . oh, but she was beautiful.

The evening ended with us coming over to my place and looking at my things. Vita wanted to watch the video that had gotten me into the academy. We laughed together. At the video. She was impressed and astonished. She thought I was tough. And absurd. Right at the tipping point between the two, she said. We watched more of my videos. And the more we watched, the more serious Vita became.

"There's really something here," she said. "You obviously have a special force."

She compared me to a smoldering volcano.

"No," she said. "You're potential energy. You're . . . you're . . . You're right beneath the surface."

We drank red wine with flushed cheeks. Vita leaned back her head, arched her throat.

"God, it's late," she suddenly said, standing up.

In a moment she'll turn around and come and sit down again. Then I'll put my arms around her. Then I'll draw her to my chest.

Her first steps were backward out of the garden while she held my gaze with her body. When she rammed into Launis's hedge, she turned and giggled. She left. She came again. She came again and she came.

The small breasts, two drops on a body of desire. There. Slap me right there, she said. I slapped, and the drops trembled, caught her fast with my hands around her throat. Her fingers gave again. Those fingers. Modeled my body without and within: Here's a hill, a ridge, a hole, she said, cylinder, triangle, and cube. A nest, a slit, a grave, a grotto, I said, piss on me, a pot. She combed my hair with sure strokes, brought my locks to general order. I grew canines. Her firm, white body. The cleft. The tightness. Eat me. I wanted to suck her tiny toes always and hear her shout in earnest that I was just as encompassing and just as insistent as the most complex work of art.

Of all my things she liked, those that behaved like a mass in space were what she liked the best, and it turned out that she was even well acquainted with some of my work. In all the time she'd lived in Sønderhaven, she'd known that I was an artist. She mentioned a work that she immediately proceeded to connect to other artists' works, an American here, and a German there.

Vita was a sculptor because sculpture was related to the body and to philosophy, to the world and to phenomena and all that, she explained. Just like many others in her class, she'd been obsessed by the French theorists that we, who attended the academy later, became familiar with as aftermath. Vita said outright that sculpture was the only true art form. All else was derived from the sculptural. A lesser form of statement.

B ack when my works existed, and that wasn't more than a cou-
ple of days ago, you know, there were three large papier-mâché
rocks and a small one, a tent made of hide, and a turf hut you could
enter. The plan was this: Four days a week settlement life would
take place in the X-Room at the National Gallery of Denmark, with
soapstone lamps, cooking vessels, and bone-carving. It would be
like a time machine: enter the museum's elevator and then, whoosh,
back to settlement life in the 1200s. A father and a mother and a
child would bustle around and do what people did back then, it
would be a living installation.

The soapstone lamp and the turf hut turned out great. The hut
was frothed up and cut from insulation foam, and then painted
gray, black, green, becoming brown turf grass. The soapstone lamp
was a tin alcohol burner. Jens from the park would play the father,
and one of his friends, someone I didn't know, would play the
mother. Launis's youngest daughter would be the child. She'd sit
and sew on something gray. The father was just returned from the
catch. He would sit and carve a bone, or something resembling a
bone, but that wasn't so solid. The mother would tend to the cook-
ing. There would be the odors of leather and dried fish.

Now the whole is black and leveled. I whisper it way down
where no one, not even myself, can hear: That's good. Shhh.

Marianne Fillerup was crazy about the settlement. She'd been on a tour I'd conducted at the National Museum of Denmark back when she'd just become inspector for the National Gallery of Denmark. Fillerup followed what was moving and shaking, she said, and it was high time the National Museum showed something like this. I had an interesting and unique way of working, she thought.

I explained the piece to Vita, of course, the individual details, the whole shebang. I was ready to haul over some of the figures I'd carved out of ivory-colored wax, I thought she would like them. It was almost like sculpture.

"Haven't you gone far enough with ironic distance," she said. "It's no joke, Justine. You're exhibiting in the X-Room. People don't buy just anything."

That thought hadn't even occurred to me. Anyway, the point wasn't to have them buy something. What joke?

Five

Grandpa was trained as a building painter, but that didn't interest him. Art, however, did. He and my grandmother lived in a ground-floor apartment in a building in the outskirts of Copenhagen. When the building was undergoing renovation, Grandpa finagled the basement spaces and outfitted them as a studio.

"Painting, my girl, is wisdom," he said. "Mark my words. If the brand is good, that is. And, unfortunately, that's not often the case."

For Grandpa it was all about the body, about its majesty and its deterioration. That meant figure studies of men and women en masse—not to mention meat. He'd stop in the middle of the street and stare intensely at some passerby, evaluating the random person's potential as a nude model and forming an impression of the covered body's lines and crevices, the skin's tactility beneath the clothes. Was it pimpled? Was it smooth? Maybe scarred?

Grandpa was productive and affiliated with an art association that had a couple of permanent exhibitions a year, and so he showed for a loyal audience in an Odense gallery.

"That's enough for me. I don't want any more attention than that. Why would I need all that hullabaloo?" he said.

He worked in the basement together with me. Instead of knocking on the staircase door, I called to him from the sidewalk beneath the window. We took the back way, down into the dark, and we closed the door behind us, him unpacking his brushes while I uncovered the paints on the palette. Together we said:

"Ohh, this is peace."

Every time he needed a new color for the palette, it was my job to find it in the tube box.

"Zinc white!" he'd growl. "Carmine!"

I organized the tubes according to shades, naples, indigo. I'd browse the rainbow and find the exact reddish-blue tint for which he asked.

Sometimes he'd use me as a model. I had to sit completely still while he sketched the motif, and while he painted, a stone was I. Afterward, when I saw the finished painting, I didn't recognize myself. My head was red and blue and pink with greenish shadows. My mouth was violet and white, and my eyes glinted yellow. Grandpa explained that that's what the colors' nuances looked like in the light. Nothing is what one imagines. Skin color, red or white, colors themselves don't exist, they must be seen in context.

"Now take a look here," he said. "Next to light green, gray looks light red. Can you see that? And next to violet it becomes yellow. Pretty unbelievable, huh?"

Colors are unstable, always ready to surrender. His face lit up when he talked about them. When he looked at me. When his gaze swung between me and the canvas, and brushes and spatula went to work.

One afternoon I came home and found Grandpa extremely excited. Before I could call to him, he'd already rushed down the stairs and stood at the door.

"We have to go to the basement right now, right now, come on, come on," he said.

"What about Grandma?"

"Why are you always so concerned about her? I've taken care of her already. What did you think? That she was just sitting up there waiting?"

Down in the basement Grandpa switched on the ceiling bulb, and a couple of steps later he was at the padlock to the studio.

"Now you'll just see what I've got. You won't believe your eyes," he said, opening the door.

A cloying scent filled the basement hall.

"One, two, three," Grandpa said and drew a paper bag off a large pile on the work table. "What do you say to that?"

On the table was a heap of bones with flesh and tendons bared.

"It's bones. Horse bones, my girl. Horse bones."

Grandpa lifted a pair of the naked limbs, he rummaged around in the pile to bring them entirely to light.

"See, aren't they wonderful. Just take a look here."

He held out a shank.

"And I got them for a song. Down at the butcher's, you know, the one right across from the station. It was pure luck. It was only because the guy the bones were meant for didn't want them. His dog died, apparently. Of course, there's dogs and then there's dogs. It was a Great Dane. That's a little dog-horse right there."

I had no idea what to say. I'd never seen so many dead animals before in all my life. Grandpa grabbed me.

"Time to paint, Justine! By the devil, it's time to go to work!"

Grandpa began his flesh-and-bone painting process. From every side and angle, with and without the meat, he painted those bones, and as time wore on, in the various stages of decomposition. The smell in the cellar transformed from a sickly odor to a stench no one but he could tolerate. The police came and kicked the door in, thinking there had been a crime. Fortunately, Grandpa was done by then. It might've been difficult to convince him he was disturbing the peace with his nonsense.

The paintings were there when I moved into the house two years ago. They stood in the garden shed on the shelves he'd built for them. Height, width and depth designed to fit the formats. I opened the shed and stepped into my grandfather's mind.

There were paintings from back before I was born. My grandmother was there. She was naked. She was dressed in blue. She glinted red.

Once upon a time she was a woman with friends and occupations, my Grandpa said. It was only after my mother was born that she changed. She began speaking in tongues at the onset of labor. The birth was long and it stalled several times. Each time the contractions returned, Grandpa said, my grandmother thought the devil had come to rip her guts out. Help me, kill him, she shrieked. Help me, kill him.

Grandpa's voice rose to a falsetto whenever he mimicked that terrible shriek.

Finally, she was so exhausted the doctors began to doubt she could have the baby, but then my mother came out, a prodigious child, blue-violet, almost five kilos.

Grandma looked pretty in the soft colors of the painting. That's how she looked, Grandpa said.

In the first months after the birth she slipped in and out of her fantasies. Finally, they engulfed her. She grew disinterested, Grandpa said, taken by a disease that had always dwelt within her body, but that had only emerged when she became a mother. My

grandmother couldn't do it, so Grandpa was a mother to my mother. When my grandmother came home after three months in the hospital, he cared for her, too, as well as minding his own work.

Grandpa had explored the same color spectra over and over in his paintings—pink, and the way gray becomes green. I borrowed a cart and hauled the paintings to the bulk waste. The next day I retrieved them again. It was beginning to rain. They hung in the heat from the wood stove and reeked. They stood in a row along the wall, lay in a pile on the floor, and then were packed in bubble wrap with protective corners and placed in Ane's attic. All the self-portraits Grandpa did from the torso up, the cadaver paintings, and many, many studies of a child's skin went to the gallery in Odense on the condition that they transfer some money to me whenever anything sold.

The first time I took him to the academy was because we were going to see the school's June exhibition. The summer day was dry and hot with plenty of sun and ease. The neighborhood around Charlottenborg, a sixteenth-century palace, and the streets behind it frothed with activity as people swept back and forth with works meant for display.

Grandpa hobbled along. On the way up the stairs leading to the studios we were bowled over by a girl who then collapsed forward onto the pavement.

"She ate a pot brownie," her boyfriend mumbled, glancing at Grandpa.

The girl pushed herself up and stumbled over to a gate and vomited.

"No, I'm not going in there," Grandpa said and halted.

Finally, we succeeded in forcing our way through the people crowding the stairs. We'd nearly reached the top and stood at the entrance to a space created by tarpaulins from a surplus stock. Beneath the canopy were pillows and blankets.

"Come in, come in," a young man called through the odor of incense. "There's just enough room for you here."

Ravi Shankar's sitar thrummed from between the pillows.

"You're not going in there," Grandpa said, grabbing my arm.

Farther back in the large apartment, on the other side of the chill-out space, Ane stood and waved with some of the others from

our group. They were drinking red. A pair of girls squeezed past us, drawing Grandpa in with them.

The painting students had divvied up the place so that each person had his own space. The paintings hung in rows along the newly primed white walls and resembled something from an expensive gallery. Grandpa wandered the spaces and occasionally halted before a canvas. And then he rubbed his thumb over the surface or scratched at the paint.

"Acrylic," he growled and it was a curse word.

"What do they want with all that junk?" he asked when we again stood out on the street.

He was an old man, one meter and sixty with his cane and a well-worn cardigan dating from the seventies, self-patched with large stitches.

"Nothing much."

"I didn't mean you."

"I'm not interested in what you meant."

I took Grandpa down to Nyhavn and bought him a whisky, but somehow he'd become stuck in the pillow room, he simply couldn't leave it.

"It smelled strange. Didn't you think so, Justine? What were they doing in there? Do you think they were smoking weed?"

"How should I know? I never even went in."

B efore I applied to the school, I went around and saw some studio spaces together with Anders Balle, a guy I barely knew. He'd entered the academy of arts the previous year. The first half year he couldn't produce anything, he said. That happened to a lot of people, but now the floodgates were obviously open and things were gushing with vigor.

We headed to Charlottenborg a Saturday evening when we were certain to be alone. All the students were gone, but their works had been left behind in the large rooms with wood floors, high panel-walls, and windows facing Nyhavn on one side and the inner courtyard on the other.

"So. Have a look around and we'll meet up again in an hour," Anders said as he disappeared around a corner.

I took a kind of running start and sprang out, or maybe in.

The first space was filled with thread. Yarn and fabric were suspended from the lofts, were stretched between the walls, creeping between the various planes like cobwebs. Sacks of clothes lay spread across the floor. There were glue gobs, there were boxes and an old loom. In another room someone was in the process of making an air balloon from some gray stuff that stank.

I tried to find the door from which I'd entered, for some reason I just really wanted to see it, and suddenly there were two doors. I opened one and stepped into a new room where walls, windows, posts, chair, and table were covered in spray paint. In a corner were

three paint buckets and some jam jars. Beneath a sink there was a box of jam jars. In the sink were some jars without lids.

I was reminded of the girl who won admission to the school after sitting for a couple of days in a large wooden box among all the submitted work. Her box sojourn was itself the work. It lasted until she was up before the admissions committee. Then she stepped out of the box and read aloud from a diary she'd kept. The girl had pissed and shit in some jam jars. She left them standing behind.

I stuck as many of the jars into my bag as would fit. I hated the fucking place. And all the fucking, jar-shitting artists.

I didn't hate them. I loved them. No. That's not how it was. I hated the ones I loved. I also wanted to be just like that right there. In that exact spot.

It was cold when I began to create my work. The cold stood right outside the windows. On the floor the paper stretched and readied itself. I wrote in sprawling letters. In Greenlandic. Burned the letters into the paper with a spirit marker and drowned them in lacquer. The alkyd flayed the letters to dun. Everything snarled and sweat stood out on my skin. I removed my clothes and opened the windows. The panes broke. The lacquer was yellow and smelled like piss. First the surface received a coat, then the deeper layers. The wallpaper disintegrated and curled and dropped off. The wind started in. In February it snowed on the floor. I drank whiskey from jam jars and tossed them out the open windows. I turned on the video camera and made a song. I moved my body in dance. I delivered the pictures, the song, and the dance to the listed address.

Grandpa took it in stride when I told him I was going to attend the academy. Actually, he didn't react. But then he heard about Ane.

"What did she do?" he asked.

"She filmed herself kicking a goat."

"Ane?"

"Yeah."

"A video? But what did she kick a goat for? Never mind. And she taped it?"

Grandpa looked disgusted.

"It was no big deal, Grandpa. She borrowed a goat from one of the other families. Then she tied it to a tree, so it couldn't escape. Then she took the video camera and filmed while she kicked it, I mean, kicked, that's not really what she did, she just poked it a little, you know: tap, tap. It didn't take ten seconds. No one could come and say it was animal abuse, Grandpa. The goat's fine."

"But can't you see it for yourself, Justine?" Grandpa asked. "That's a damned insane thing to do. Kicking a goat? That's never been art."

"Grandpa, trust me. That's art. I could try and explain it to you, but I don't think it would help much. You'd still think it was ridiculous."

"You can damn well try. In fact, that's the least you can do. You can't just say it's art, and that's that. Tell me, Justine. What is it that makes kicking a goat a work of art?"

"Mainly because Ane says that it's art. And because she's going to the academy, of course."

"But how did she get in?"

"With the goat, Grandpa . . ."

"That's completely absurd. Can't you see that? It reminds me of those idiotic videos where people film each other in all sorts of stupid situations, like when they fall on their ass or get their pants soaked or something. That's just as idiotic," said Grandpa. "But you don't make things like that, right?"

The new students gathered with the old in the academy's banquet hall with its gold chandeliers and antique plaster friezes. The rector talked about art's necessity and about the great masters whose steps had graced the courtyard's cobblestones. It was a great honor and a great responsibility to be a student in the castle. We were already becoming a part of history.

Grandpa thought it was all a lot of snobbery, he couldn't care less about the overblown place, he said. Nothing good would ever come out of it. But we who were released into the castle's corridors hurried to find the place that would be ours. I had nothing on me but some India ink, and I wrote my name on a piece of paper and stuck it to a wall. A moment later Ane appeared and staked out a spot next to me. In reality, she said, she'd mostly done drawings and watercolors before applying to the school, but when she was working on the application piece she'd talked to one of the academy's professors a friend of a friend had put her in touch with. The professor had said she shouldn't apply with her paintings. They were too emotive, he thought, and way, way too nice. They lacked bite, distance, that something that gave them artistic legitimacy. Ane thought she'd fooled him, and she enjoyed the fact that she was now free to drop goats and videos and continue with the paintings she'd always done.

We flowed together. The whole studio flowed together. Things whirled around. They entered through doors and windows. Boxes, tables, chairs, more boxes, buckets, pots, jam jars, lamps, paints,

stands. It wasn't too long before the janitorial staff could no longer tell the difference between what was trash and what was important.

"The difference between whoever made this piece and you is that you want people to experience something in particular. They just want to make you aware of the fact that you're experiencing," I said.

"I never wanted people to experience any particular thing," Grandpa said. "They can think and feel whatever they want."

"I don't know how to respond to that, Grandpa. I actually think it has to do with the fact that at some point the brain simply stops trying to understand."

"What the hell do you mean by that, kid?"

I slammed the door so that the window rattled in its frame. A moment later he came out into the garden. He took the deck chair from the shed and opened it next to the chopping block.

"There's enough wood for plenty of winters, Justine."

"Do you plan on moving any?"

"Remember that I've got to be able to stack it."

"I'm not a child, Grandpa."

Grandpa sank heavily into the chair.

"No, I'm well aware of that, Justine. I'm well aware. It's just that I'm getting a little fucking old."

"That's what I've been saying all along."

"But no one is going to fucking come along and tell me that my senses aren't intact."

"All you're missing is the metasense, Grandpa."

"What kind of sense?"

Anders Balle was with me when I created my *piniartorsuaq*, my great hunter, a woman named Inngili. Inngili was me, and I was her, and it was great, we could simply inhabit the same body.

Inngili and I accompanied Balle to Nordsøcentret in Hirtshals. We wanted to take some shots with animals, preferably seals. I'd arranged things with the aquarium's head, and Balle had rented some camera equipment for seventy thousand kroner from Zentropa, where he had a contact. We were well prepared. Balle would take the photographs so that I could exclusively concentrate on Inngili and the animals. Bear skin trousers and a white anorak. I didn't just look it, I was a real hunter.

The seals reclined on the artificial rocks, there were quite a few of them, at least twenty. It was like the olden days, said Inngili, back when there were seals all over the ice. Lounging. Distending. I wondered if I would be able to instill life in those that were dozing, but then a pair of the seals glided into the water after all and frolicked about, barking. Back on land Balle got the camera equipment in place, and I climbed up to the highest rock and surveyed the landscape. A hefty sea dog yelped, rolled over to one side, and fell asleep again. Anders stood behind the camera's eye and yelled that I should play a hunter on the way home with my catch.

Ahh. I turned my weather-beaten face to the sun. It had been a bountiful day. In a pool surrounded by ice, the water still seethed with animals. On the ice, a bearded seal flock lay gliding along in the afternoon sun. Time to set for home before it got too dark and

cold. The dogs jumped for glee at the sight of the catch and pulled impatiently at the sled's traces, they knew they would get a share of the spoils, but they had to wait until they'd delivered it safely home. I tied the three seals securely to the sled. In the distance a snowstorm was brewing. Time to be off.

"That was a good catch we made there," Balle said on the way home in the car. "It'll make for a good photo series. How will you show them?"

"I can provide for an entire settlement if it comes to it. There aren't many women who could catch three seals in one afternoon."

"Nah, you're a cool artist."

"I'm hungry."

"I damn well bet you are."

Six

Bo chews in his sleep. He's back from a concert in Femøren. He bashed his forehead on the closed door. He collapsed onto the mattress. He was very drunk and very silly, he laughed and laughed and got stomach cramps and gasped: Oh, oh, make me stop, and then he laughed himself to sleep.

That gold, taut stomach. The skin glitters beneath the pubic hair in a soft band up to the navel up to his chest. The slack body, the hard body, it rises, it sinks, the nipples float, come to rest beside his chest. Flesh. The carotid's nervous pulse, thud, thud, thud.

I'm Inngili. I can perch atop him and ride. In my hands he's an animal I'm bringing down. I'll ride him like he's never been ridden, until he spurts, until he dies. I unzip his pants. There's softness in the warmth between the hairs. I ride him with my hand. I transform him to a fountain that shoots high into the air.

Oh yes. Rock that cunt, driver, bundle me tight, wolf.

Now it's morning. He scratches himself. Gives me a lewd look. "Keep your pants on," I say. "Nothing happened."

Yelp.

He groans, scratches himself a hundred places at once. Then he steps out and whistles while he washes.

Aren't you sticking around, man? Else, I'll have to work.

I don't say it too loud. He doesn't hear anything and leaves. I stick around.

There's a floating fuzz. It hovers, ascends, and moves straight to the right, ten centimeters, I think, maybe twelve, and then it hovers again. All of it. No matter how I approach things, it's the wrong way. I blow the fuzz that takes a decent flight of more than a meter, and then I need to drink more. Thinking makes me so thirsty. I think so much I've perpetually got to pee. Yet again. Every time I sit a moment and am about to have an idea, that's it . . . off to pee.

I find my telephone in my bag and call Marianne Fillerup at the National Gallery.

"Keep your pants on," Inngili says in an authoritative voice, putting a lot of space between her words. The works are safe. They're currently up in my friend's attic. Fortunately. Marianne Fillerup groans.

I hate the telephone, that shitty apparatus, and switch it off before I end up dialing someone else. I need to pee.

A ne sits on a bench in Enghave Park. She was pushing the baby in the stroller, but every time she'd let go, he'd wake up. She didn't get to do her shopping. Now she's tired of walking and parks the stroller in the shade where she can keep an eye on it. Soon he'll wake up, but that's okay.

"There's really nothing to say," she says, "about Marianne Fillerup wanting to see how much progress you've made. She's responsible, after all."

And she adds:

"I mean, you're not all that bright. What are you actually going to do?"

The last two sentences are the most accurate that've been spoken in a while. They're true. And relevant. I'm not all that bright. And: What am I going to do. I isolate the sentences in order to remember them.

"I'll pocket them," I say, "these sentences."

Ane's at it again, in the process of lifting the stroller cover to peek. She says:

"Now then, little man, you're awake?" She removes the cover. "You've had a good nap, love. Are you hungry?" She takes out her telephone and checks the time. "You slept for two hours. That's right, two hours," she says, lifting the red-cheeked baby from the stroller. All in one movement. Now she fidgets the baby to her breast.

"I'm moving to a hotel here in Frederiksberg," I say.

"What's that? In Frederiksberg? Can you afford it?"

"I can't stay at The Factory another day."

"Yeah, I'm really sorry about that."

"That's not what I meant."

Of course I can stay at The Factory, I just might have to. What I'm saying is: I won't. I don't know. I can't. I can't fucking do it any more. When I say that, I get a sense of deep, deep depth. Can't is the empty space at the end of every branching possibility.

She prattles about Torben everywhere, at home, on Nørrebro, on the Bryggen wharf, and now she's talking about him again here in Enghave Park while she sits and nurses. He's apparently fed up with his gallery. They want him to participate in a group exhibition themed around *A Man's Answer to Feminism*. However, Torben doesn't like working with themes that way, Ane says, he's sure they're just waiting for an excuse to get rid of him because they think he's difficult. She's annoyed on Torben's behalf, and it's made worse by the fact that his gallery has also contacted her now. She thought they wanted Torben, but, as it turned out, it was Ane they were looking for. The gallery owner would like to see some of her things, just informally, you know.

"I'm telling you, Torben got weird when I told him that," she says.

She tucks away the limp breast and removes the firm one.

"I just said I was on maternity leave. Obviously, I don't want to be in the same gallery as Torben. Nothing good would come of it," she says.

Vita's still not home, but I didn't expect her to be, either. I chose this exact moment. The vegetables in the box on the kitchen table, they're hers and where she's still an absence, have grown brown tops. They hang over the edge along the table's surface and yearn for water, which probably hasn't run in days to judge from the sink's dry metal and the calcium deposited there. And there stand the two glasses with their big, round red-wine bellies, their dark edges and the impression of lips and skin.

The couch is waiting in the living room. I lie down on it, down among the cushions.

Someone is rummaging around the fire site. I passed by and looked the other way.

In reality the settlement, which should've been, but no longer is, and which makes my stomach flutter, is a continuation of the work I created for the National Museum a year ago. I received permission from the museum's director to give a special tour four Saturdays in a row on the condition that I made it very clear that the tour was unaffiliated with the National Museum in any way. Before I began my spiel, that is, I had to remember to emphasize that it was an art project. That's what the signs should say: An art project.

The guests flocked to participate in whatever was happening with the Eskimos in the ethnographic collection.

"My father's mother, Inngili, was a great hunter," I said, "and that was extremely unusual for a woman at that time. Back then it was mostly the men who hunted, but Inngili had made a pact with the animals: If they let her capture them, she would do it with hunting gear that was superb and beautiful. No animal likes being downed by inferior hunting equipment, and my grandmother knew that. Therefore, she made sure to adorn her harpoons and could easily come home with seven, eight seals in one day."

People peered into the bright showcases that displayed the harpoon with the decorated shaft; the wood and the bone trimmings glowed. It looked so splendid behind the glass, the way the halogen lamp was positioned, it was entirely perfect. Wood and animal grease. And the years layered in.

"My grandmother's harpoon was stolen from her by a whaler named Wilhelm Löwe. Löwe also stole a small *ulo*. You can see it over here."

On another wall hung the women's knives with their handles of bone and tooth.

"Herr Löwe sailed with a whaling ship from Holland. He was the ship's captain and had sailed most of the world over. But he also came to Greenland, where the whaling was good at that time."

I drew the group over to the *ulo* display case and pointed out an especially beautiful knife with a fine tooth handle.

"My grandmother's knife," I said, "shouldn't be hanging here, but that's what it's doing, unfortunately . . . There was always a celebration whenever a foreigner came to the settlement where my grandmother and grandfather lived, and there was dancing and singing at my grandparents' home. When Löwe landed, my grandfather was on a hunting expedition, so when Löwe fell for my grandmother, he had free reign. She was so clever and different, he thought, different than the other Greenlandic women. Löwe pursued my grandmother the two days his ship lay in the harbor. What exactly happened, she knows only, but when the whaler again pulled anchor, my grandmother's *ulo* and one of her harpoons was gone."

The guests listened and nodded and saw Inngili before them, the beautiful Greenlandic woman with all her hunting gear. I told about my great grandfather with his bushy brows and grim words, he'd been a priest in the colony, hallelujah. Herr Löwe succeeded in raping a twelve-year-old girl before he scampered off with my grandmother's possessions. Löwe had to leap from the edge of the ice to escape my superhero of a grandmother. She pursued him with my grandfather's harpoon and struck him in the thigh. She was wild and frothing at the mouth. She wanted to murder him. The swine. Another time I said that Löwe had eaten himself sick on pickled auk. My grandmother had to care for him until he was recovered, at which point he hightailed it with the swag. Those tales were invaluable, more than priceless, they were . . . they were . . . indescribable.

Vita came and spied me between the kamiks and the kayaks. She'd insisted on knowing when the tour was taking place, she'd love to see it. Ane was there as well, and the curator Ulla Lund arrived together with Marianne Fillerup.

The words leaped and danced from my mouth, it was a song. I levitated, in front of those women I absolutely levitated.

"You own the floor you're standing on," said Vita. "Thank you for including us."

Her gaze sucked me in.

"You're so radiant. And wonderful."

"Yeah, she's good," Ane said. "You should see some of the other things she's done."

For the occasion I'd put a thick burgundy ribbon in the bun on top of my head.

"Thank you for a fine performance," Ulla Lund said. "Have you met Marianne?"

"Where do you get your material?" Marianne Fillerup asked.

"What were you thinking of in particular?" I asked.

"Oh, all of it. But maybe we should get together some other time and talk?" she said.

We arranged a meeting in the glow of Vita's pearly skin, which radiated in my direction.

Vita's ankle-boot heels clicked sharply on the way to the bar where we were going to drink a celebratory beer. She slid on the cobblestones. I caught her. Ane and Vita seated themselves in a corner,

they had no difficulty talking, Vita's reserve was entirely absent. They chatted, laughed at the same things. Ane asked Vita for stories from her time at the academy. Vita was Venus. She placed her hand on my thigh beneath the table and talked about professors, about sculptors and materials and projects. Everything was in its proper place. Ane and Vita talked. I ordered beers. What I'd said during the tour and the reactions and the custodian who'd stopped and listened, and the light in the room, Lund and Fillerup and the sound of the floor beneath shoes, and the dry, stable air, and the perpetual awareness of Vita's scent, it all came rushing back.

The clock empties its contents into the streets and alleyways and into the factories. It flows away in the shape of hours and days, and nights are long, nailed in place, I watch time rise. Soon I'll nearly be up to my neck in weeks, and everything has never been so far away. I'm drowning? Here comes the ivory-colored wax floating along. Past. And the true to life bones. Floating right past. And over there. Huts and blankets and skins are rocking in the water. Here the Eskimos come swimming. Their hair is matted in thick tufts. Their smell is harsh and strong. The women with hanging breasts and nearly toothless mouths paddle. The men stand further in along the coast, distant and perhaps hostile. Two children disappear over a field, race down to a river. The trout hover like torpedoes in the restless time between my legs. I step onto a stone. Day. The night has been reduced to a turquoise rim on the horizon. I focus intensely on the sky. Now shouts are sounding in the distance, numerous and piercing. The great hunters have returned home from the catch. The women are already dragging the fat seals along, laughing and shouting. The children come running with the great catch clapping on lines. They're all together now. Inngili opens her mouth and shows her four teeth. She slices a strip of liver dripping red turning black. I chop the whole into small pieces and send it away with the stream. And here comes my great grandfather striding along, slightly out of chronological sync he marries ten wildlings at once and bids them welcome to Heaven. Tiny, bow-legged women and men. Turn around and depart. In the opposite direction. Away, Inngili. I can't take anymore. I can't take anymore. Farewell.

Farewell? What remains, then, if not that which has endured so long it's perpetual? What's the alternative? Yes, who's the alternative? The me that is now is formless, not exactly dissipated, but flailing around, thrashing, reflecting off windows and surfaces. Everything changes so quickly, I can't grasp it before it's gone. Is it just light and movement that speeds off to wherever? If I use aperture eight and perhaps attain a hundredth part, can I reach it then?

I'd like it to see me. For it to position itself over there and tell me what it sees when it looks at me. I don't care what I am. Just that it shows me how I am, from all angles, at all moments, no buts about it. Now I just need a camera.

Seven

Behind Ane, the apartment has a particular light. Umber. Sheets obscure the windows so that if the sun is sharp, it doesn't hurt her eyes. She hasn't been sleeping well at night, she says. Torben's coming now, he forces his way past me and disappears into the living room, but he appears again in the doorway, shirtless and in his underwear gives me a look.

"It's in the kitchen," Ane says.

She's talking about the camera I'm going to borrow, which she got from her father as a maternity gift. It's already taken thousands of pictures of the baby who's sleeping on her shoulder.

"Let me show you how it works," she says.

"Do you have the manual? I can just read that."

She rummages around in her bag and hands me the booklet.

Torben has put on a T-shirt, but he's still in his underwear. His body cuts my body on the way out to the kitchen.

"May I take a bath?"

"Of course."

I stand beneath the showerhead. The fish odor persists on my skin, in the oil and the folds. I unhook the sprayer and stick it between my legs.

"Are you almost finished, Justine?" she calls. "What are you doing in there?"

"Bathing."

"You've been bathing for an hour."

"Thanks for letting me."

"So, Torben is waiting on me. We have to go. Can you just lock up?"

He's standing in the hallway outside the door and waiting on her—or on me? Under some ridiculous pretense or other, what does he want?

I pull open the shower curtain and douse my lips, press the sprayer into their softness, rinse their depths of semen. The dog. If that's what he wants, he'll get it. He stands lurking in that despicable way, his eye against the hole, staring. The water flecks my body around the nipples that swell, my body is three pulsing buds. Bared.

The apartment is empty. He wasn't there at all. Or was he?

I've got a camera now, it's a good place to start. I feel like I'm on such secure footing, it simply can't go wrong. Now I've just got to take the pictures. But before that: I need a tripod, then I can do it myself, do myself, timed release.

Trine Markhøj sits in her studio among tools and wood and plaster and clay in plastic sacks piled around a square podium. On the podium is a plastic-packed figure on a modeling stand. I've just knocked, but Trine doesn't look up.

"It's gone totally downhill," she says. "It'll never, ever amount to anything."

She leans on the figure that resembles a bowed body beneath the plastic.

"Careful!" I shout.

The small amount of pressure she's applied to the body puts it on the verge of collapse. Now it's happening, bending backward in a sluggish movement that accelerates abruptly until it topples onto the floor.

"There," Trine Markhøj says. "That's that. What can I help you with?"

She hunts for the tripod beneath the table and behind the cabinet.

"What a good thing you showed up," she says. "That was just the thing. The last little push. It never would've amounted to shit anyway. Just think, sometimes you can't see it yourself."

She pulls out a wallpaper roll and a pair of fishing rods. I tell her to leave off looking, but it's no problem at all, she says, and continues.

"See, I also found my water hose."

She tugs the end of a green hose that proceeds to unwind. Beneath the cabinet she finally finds what I came for: the camera tripod.

"If I need it, I know where to find you," she says, and transforms to clay, brown masses fall and pile on the podium like a tower.

Bo's come. He asks if I want to go to Vega and hear some reggae, dry, sharp.

"This tripod's fucked," I say.

I fidget with and press on Trine Markhøj's tripod, what a piece of shit. Bo grasps the tripod between his hands and unfastens the clasps one after the other, adjusts, twists a little lever with a gently rotating wrist. The base rises, shooting out of its cocoon.

"So are you coming?" he asks.

His body nears, wrestles the tripod into a relatively balanced position. Three legs and an appendage. I whack the appendage that dangles and droops.

"Stop it," he says.

"I'm deciding," I say.

"Don't you like reggae?"

"Did I say that?"

He leaves.

I'm left with three legs and unsteady, limp hands turning a lever.

Vita will not, she doesn't want to, she simply will not answer the phone when she sees that it's me calling. No. Vita. Why the fuck is she being so cold? I want to call and ask why, why the hell . . . I'll think of something to ask . . . and then she doesn't answer.

Someone is knocking on the door. Ane walks in with the baby in a sling on her chest. He's sleeping.

"Torben's application has been turned down," she says, waving away Vita's ghost with a hand.

"We were really counting on him getting that grant. They know good and well we're new parents . . . and how much the money means to us," she says and starts crying.

The baby wakes up.

"Have you seen her?" I ask.

"Who? Who are you talking about?"

"Vita. I'm talking about Vita. Have you seen her?"

"No. But . . ."

Ane stops crying and that's good.

"Wasn't she going on vacation? Wasn't she just talking about that?" she says. "I don't know what we're going to live off of. I just don't know."

The boy starts crying.

"I just wish something in life was dependable. I can't take this. Shit, we need something to live off of. What about when I finish up . . . we'll just have nothing, I guess? Spit out into reality with no food and no clothes."

She's taken the stroller and rolled home again, home to Torben. She's left me with a dull feeling. I know she's right, and she knows it, too, even though we pretend it's nothing. It's bad enough with Torben, he deserves to get the short end, but there's an even bigger problem for Ane. Myself I don't even want to think about, just forget it. We discovered it right when we entered the academy of arts, and now the smoke's in the clothes.

At one of our very first joint critique sessions, our painting instructor told us that it was likely that just one, maybe two of us, would ever amount to something, would continue doing art. But he said that he thought we should just drop it, quit for our own sakes, that it was a mistake that we'd ever entered this arena. He didn't think it was possible for us girls to create anything truly interesting. It was always about womanhood, motherhood, or something else sweet and funny and cute, small animals with big eyes, fairytales and feelings. You're terrible concept artists, he said, and meant it.

It was a spoonful of flour in our mouths that we believed to be sugar. We sucked and sucked and thought we'd heard wrong. The instructor's eyes swept over us while we stood pressed together in a workshop stall across from the five paintings that were being critiqued. The paintings showed a woman in different stages of dissolution. Mascara ran down her cheeks. The woman held a wine glass in one hand and a cigarette in the other. The painter in question had slack shoulders. But then the instructor said it wasn't necessarily her he meant, she really was very sweet. Ane sat and pressed

herself into a corner. A couple of weeks later she was scheduled for a critique session with the same instructor. It was already on the calendar.

One Friday after a bunch of openings we had met our painting instructor in the city. He was standing at the bar together with a couple of professors drinking highballs with ice.

"Bitches," he called.

Me and Ane and a girl named Katrine.

"Girls, come join us for a drink."

The first professor downed his drink and had trouble walking away. Our instructor stared at us and called for the bartender to hurry and bring three double Havana Clubs.

"You're all three beautiful as goddesses," he said. "Come on, girls, come, come, come."

He hustled us between himself and the remaining professor, who followed his colleague's example, packed up, and left.

"Hey, girls. It's just us now," the painting instructor grinned, guzzling his highball and ordering another.

Katrine left on the excuse she was going to the bathroom.

"Well now," said the instructor. "Ane. When are you going to show me what you can do?"

Ane blushed, but the instructor drew her closer and kissed her hair.

"Fuck me, you're so hot," he said.

I kicked him in the shin. He jerked back, still with Ane under his arm. His drink splashed over her and down my arm when my boot struck, and he stiffened. Ane twisted free and left.

"Hey," he said. "That wasn't what I meant."

He set his glass down.

"Excuse me," I said.

He looked completely off. I thought he was about to start swinging or shouting.

"You're welcome to see my things," I said.

"I don't know anything about videos," he said.

"How can someone know nothing about videos?" I asked.

"I don't like watching them," he said.

"What are you drinking?"

"Rum."

"Two rums," I told the bartender. "I also do things other than videos."

"Talk to Ole Willum," the instructor said. "That's who you should talk to."

And he downed his drink and left.

Rikke's standing in front of the gate, Rikke with the soft arms and big hair, the person who's so preoccupied with herself and her career and others, including me. As soon as she sees me, she shouts that she heard about the fire from Per Olsvig. I don't remember saying anything to him about it, but yes, I did.

Rikke, whom I know from Juanna Gomez's guest instructor days, is someone I'd really like to avoid, just like that, but I'm sucked in her direction. Much of what I decide gets nullified and now, against my will, I'm on my way over to talk to her.

"It's totally surreal that your house should just burn like that when you think back to your experience with Juanna," Rikke says. "If it weren't for the fact that it was so long ago, someone might almost think it was a piece you'd set up. Did you film it?"

"What do you mean?"

"Well, the fire?"

"My camera burned along with everything else. And my computer."

"But what about that exhibition you're having? Isn't that just around the corner? What are you showing?"

"Paintings, I think."

"Okay? Crazy. Is it anything I can see?"

"Sometime or other."

"We're just in the process of researching an exhibition, and I was thinking . . ."

I'd like to set her hair on fire.

Juanna is a Mexican artist our professor, Gretha Müller, knows. She works with psychoanalysis in her works, and with hypnosis. The first thing she did when she came to the academy was to lie us down in a circle. Rikke, who never misses an opportunity, and who always participates in the good exhibitions, and who generally gets a lot of things handed to her, whispered that a number of places ached within. One of the other girls admitted that she'd consider murdering a certain person if it weren't for the fact you'd get punished. There was also someone who thought he was a vampire. He'd seen an a video online and now he knew there were others who, like himself, longed to taste a woman's blood.

Juanna had learned hypnosis from a relative and she thought it was important that each of us try it out. Rikke was anxious to see me enter a trance. There was no reason not to do it. I wasn't afraid, neither of the trance nor of Rikke.

"Stay calm," said Juanna. "Most people don't even realize they're hypnotized. That means there's nothing bizarre or mystical about it."

Juanna's snake eyes stared into mine. She said: "You're completely relaxed. That's right, good, very, very good."

My neck hurt, I wasn't relaxing at all. My eyelids fluttered, danced, wouldn't stay shut, and I itched everywhere, behind my knee, beneath my foot.

"Now you're completely relaxed, yes, completely relaxed, that's it," Juanna said, "just close your eyes."

"I can't keep them closed," I said, "because then they can't see."

"But you're already seeing. Now you're seeing. Just let your eyes see whatever they want to now."

I rubbed my eyelashes as they closed softly over my eyeballs, and suddenly I saw them: flames, and a woman in their midst with sparks leaping from her forehead.

"Tell me what you see," said Juanna. "You can tell me."

"But you're burning," I shouted.

I opened my eyes and saw Rikke burning, she still smelled of grease and flesh.

Rikke thought it was a strong vision, strong and violent, and she was curious to discover what lay beneath it.

"You should've stayed there," she said. "You were on the verge of something really important, I think."

She wanted me to tell her about it, but I said that since I was no longer in a trance it was pointless.

"That doesn't matter," she said. "We can still analyze it."

During the last two days of Juanna's visit, Rikke talked a lot about the fire. For some reason she was obsessed by it, she was eager to see me transform it into a work, and she would make sure the work found its way into an exhibition. Juanna liked the idea, and I thought I'd try to make something out of it. So one afternoon during the vacation I set one of the school's basement spaces on fire and then quenched the flames. Where the flames had consumed the paint, the walls were black and gray, and a small window looking onto the street had cracked in the heat.

Rikke came to see my work. Her face was expectation become disbelief. Then she caught sight of Ane's drawings, forgot the fire and asked Ane if she'd considered of showing them, they were really great, she thought. Ane said it was certainly possible, but where? I stood at a fire site and observed Rikke standing there, consuming Ane and Ane's drawings.

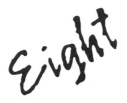
Eight

Vita towers up, stands white and blue, spreads her bones, bares the wound. Hack. I reach my hand up, scrape the skin with my fingernails to rare meat, red and sticky.

"Tell me, who do you really think you are, you, you there, yeah, you there, you just lie around and tinker and scrape."

"You have a nice little button there, right above the hole, swollen and shimmering red, almost cerise," I nibble at the button lick my fingers fondle.

"Will you piss on me?"

"Tell me this—just who do you think is pissing here, woman? It's not me," she says.

With her fingers she parts the flesh reveals an opening, small, fine, forces the drops out, and red washing to yellow falls gold on the skin on the face on the pillow.

She'll be happy when she hears the whole Greenlandic thing is over, when she hears I've sent it packing up the river toward the falls. Other things have dissolved into ash and smoke. No more dead fish, huts, drums. The drum I'm actually sorry to have lost. It was, to me at least, as beautiful as hide and hell.

I made it from from a piece of skin I got from the butcher. At home I washed it in water and brown soap, I rubbed it until the fat was rinsed off, and then stretched it over a barrel hoop. When the skin dried, it became firm and elastic, almost transparent, and then all it needed was a handle. The sweet reek of grease and hide filled the house.

Vita couldn't stand the drum because it stank, she said. It reminded her of death, the whole house reminded her of death and brought to mind the fact that Grandpa had died here at home with me.

Grandpa didn't stink.

She suggested that I operate with those themes, death and skins and such, on a philosophical level, or an artistic one. Dead skin is something one discards, she said, because it's chock full of bacteria. I told her that the hide was cleaner than a person's ass. I told her it was art, perhaps not sublime art, but fuck me, it was still art.

If only she knew that a guy in a band had hired me for a concert after he saw me perform with my drum. He couldn't stop touching it.

"I mean, it's just so organic," he said. "And soft."

I told him my time was dear. He licked the drum and said it tasted like a deer. I said a wild animal lived in that drum. He laughed and covered my mouth with my hair. I forced the drum down over his head so that the skin cracked and split, but it couldn't be heard over the night's uproar. The party had expanded in all possible directions, way down to Sønderhaven.

We ran ducking past the brick house, but then the guy suddenly popped up and shouted over the hedge to Vita:

"Come out and fight like a man, if you dare."

I kicked him in the shin.

"She's not a man, she's a dog. A bitch," I said.

"What are you talking about? Is she your girlfriend? For fuck's sake. Are you a lesbian?"

"Wolf."

"Well, then shouldn't we ask her if she wants to join?"

"That bitch will eat you up and spit you back out."

We galloped guffawing to my place.

"I'll show you something strong and organic," he said, tossing his pants aside as he walked in. "Soft as a grub, strong as a lion."

He took the dark muscle in his hand. It really was huge. And soft. And hard. The head beamed atop its swollen stalk.

"What a sight," I said. "Let me blind it."

I took it between my hands and drooled on its eye.

"That's it," he said. "Blind him, he deserves it. Greet him and eat him."

Vita said she didn't want to come over, not before she was certain I'd thrown the drum out. She was scared of what she might find if she were to open a drawer or lift a pillow, something nasty, something rotten. It was only the one drum, though, and it no longer exists anyway. The fact that she didn't want to come over was much more threatening.

Yet now, dear Vita, no more of that. You get it, right? I don't care anymore, I just don't care. Now it's happening. Something else.

In the hotel room there's a desk with a wall lamp, and at the desk is a chair. I've used that chair to sit everywhere in the room. The camera is still on the tripod, but it has yet to take a picture. I just don't know what to aim it at. The apparatus stares at me with its black eye, I think: What should I do? Now I'll pick up the camera. I pick it up and do something with it, turn it on, peer through the lens, direct it at the street, at the people below. The building next door is a temple and the choir that's been practicing is taking a break. I zoom in on a large woman with thick legs on bent heels and think: soprano. Next to her is a man with a beard. I think: beard. Then I think: Now I know what I'm going to do. I believe.

I sit on the chair in the center of the room and take two pictures using the self-timer. After that I take off my shirt, sit back down and press it twice more. On my shoulder I draw a tattoo, *Butch*, with a magic marker. I look tough and dykish and take a couple more self-timed shots. Next to the window it occurs to me that it would be nice to have a Salvation Army uniform, maybe a banjo or a ukulele. I think the latter would fit better, even if it doesn't really fit at all. How can it be going better after just, yes, fifty-five minutes and around ten pushes of the self-timer. But it's going better, and I pack the camera up. Now I'll head to the thrift shop to find some clothes and other things, perhaps some shoes.

It goes so well that I don't even notice that she's called several times. Now she's calling again. Now I notice.

"The police have been out here," she says, sounding quite matter-of-fact, with an odd buzz on the line.

"They're obviously continuing their investigation. I assume they think it's arson."

"Arson," I say.

Not questioning. Confirming.

"I don't know how they can tell something like that. They rummage around. Dig in the black. Overturn boards. They have magnifying glasses and gloves," she says.

"Okay," I say. "How's it going with you?"

"With me? It's going. I'm on a faraway continent."

That thing she says about faraway, that cuts. She could've at least called earlier, isn't she interested in how I'm doing? After all, she has time to go and ponder that sort of question now.

"Do you still have my spare key?" she asks. "You should hurry up and get rid of it. You should stay away from my house. It's not good for you to go there. I've noticed that you've been there multiple times. It's not a good idea for you to be sleeping in my bed."

I can tell by her voice that the price for saying such things is high, and now it's buzzing even more.

"Anyway, I hope you find out something. You should call the police one of these days, I think. You should also call the National Gallery. It's no good having it go through me, Justine."

Silence.

The darkness is pleasant. His breath and the heat flowing from his skin dampens us. We're lying close together. After a few minutes the warmth becomes water that pours between us and wets the mattress.

I draw away, I just can't take all this closeness any longer, but Bo follows me in his sleep, rolls with me over the narrow mattress and onto the floor.

"Hey, where are you?" he asks.

"Right here," I say.

"I thought you'd gone."

"No. It was just hot."

He pulls me back and throws his thigh across me, now we're together again.

"I was dreaming," he says.

"About what?"

"About this Saturday. The kitchen."

His hand finds my damp breast. My body can't do it anymore, but now my nipple contracts, racing through my body to my crotch.

"I'm dreaming about ice cream," I say. "Vanilla ice cream with raspberries."

"Something like this?"

He squeezes my nipple and laughs soundlessly.

"I'm dreaming that you're serving me something. Or that you're taking me one more time," I say.

"I don't know if I'm up to more," he says.

He raises onto his elbows and now I'm sharply aware of the moistness from his mouth.

"Of course I am. You're something really, really special. What do you want?"

"How am I special?"

"I can't explain it, but allow me to demonstrate."

He rises from the pallet and walks through the dark away from my nakedness.

"I don't want you to go," I say.

"I'm coming right back," he says. "It'll only take a moment."

"Don't," I say. "I don't need anything."

He comes back and crouches beside me.

"What about the ice cream?"

"I'd rather not."

"I can grab it in a second?"

"Screw it."

"I can easily grab it. And if there's anything else you want?"

I touch his shin. Finally, he collapses beside me.

"Come. Lie down on top of me," I say.

"Like this?"

"Yes. You're wonderfully heavy."

"All flesh and blood."

"Something's full of blood."

"Yeah, it is. You're going to get it. And you are something really special. I already said that, though."

"Special how?"

My arms can reach all the way around his torso, I squeeze, oil myself with his dampness, his body, and his smell. His engorged member rubs against my thigh. Luckily, he's not circumcised. The skin is elastic and soft, and the animal inside slips lightly back and forth.

"Especially greedy."

What was it she said? Something about her just wishing I'd flown? She would've liked it if I'd just sat on one of my hides and flown off to hell? Or did she say she'd like to cram the hide down my throat? She'd like to tan me, cleanse the shit out, cleanse me of filth? Did she say anything at all? The evening it burned.

I don't remember the whole of it, barely the half. Glass shards. She sat there cracked at the edges, kept her calm, swallowed the outrage, oozed us onto the glass strewn about. Now I know what she said, because I remember it. She said: "Ready, aim, misfire."

No, she didn't. She'd never come up with that. It's too childish. She said:

"You're being a child. Smashing things doesn't help."

Or something like it. In any case, she said I was childish. And I said:

"I'm a child."

She agreed.

"An annoying glass child."

No. Glass is just something my brain has conjured up, it's a good image to have when things go to pieces, my brain thinks, and so it conjures splintering molecules and glass.

"An annoying child."

Yes.

Does she know where it strikes, that viewpoint? It whizzes through the air to come cascading around me as splintered glass. Now all that remains is the image of the child sitting inside the armoire. Not the child. The image.

Is it even possible to find a cut-off? An exact moment when it all went wrong? A point around which all events are distributed? Before the after? A crime scene? A weapon cast in a backyard? The road to murder is a slippery slope of things that are said and done. An eye that saw amiss. Something that should've remained hidden. Or something that didn't happen. After the murder there's the clean-up. The cover up. Someone must pay the penalty. Others must receive it.

Vita had some sculptor friends she occasionally met with. They talked about enticing jobs and saw exhibits they found exciting.

The circle consisted of three women who'd once shown together. However, over the years they'd gone in such different directions that it no longer made sense to refer to them as an artist group, Vita thought.

The other two women were exhibiting in Nikolaj Kirke. Vita hadn't seen them in a long time and was both looking forward to it and not. She tossed her things around the living room and tried on three different pairs of shoes before settling on an old pair of boots.

"Can I borrow your lipstick?" she asked.

We arrived at the church in a flurry of lipstick and activity after the opening was already underway. One of her friends had constructed a giant table and fourteen chairs out of unplaned wood.

"The man she's standing there talking to—he's from the municipal procurement committee," Vita said, pulling me close.

The table was set with plates and a massive flower arrangement in porcelain. The floor was strewn with sawdust.

We headed into the church and met Vita's sculptor friend Hilde, who waved a greeting and came over. From the outside all was fine. The women chatted loudly, the space resounded with question and assent. After a moment the other friend, Eva, joined them. She'd made a tile walkway that stretched across the floor and up over the wall and two posts before heading to the bar.

Vita's face softened. She called us girlfriends. We kissed with our lipstick.

Hilde's stomach bulge was obvious, she was pregnant with soft hips in a tight dress that she kept tugging down.

I walked the path to the bar. When I came back, a man with bushy brows over his brown eyes had joined the group. He was Hilde's boyfriend. He also knew Vita, he said, and smiled with his mouth. How violent he is, I thought, violent and radiant. He barred his teeth, big and sharp, almost like they'd been cast. A predator.

Hilde and Vita disappeared. Eva was nowhere in sight. Hilde's boyfriend fetched more wine and talked about a house they'd just bought in an allotment society in Brønshøj, and about his work restoring old furniture. He'd also seen Sønderhaven, he'd fallen in love with my house while there, postcard perfect, he called it.

All the while there were the teeth and the smile playing around his mouth. The room dissolved and fell away. In the darkness outside the church we met between the buttresses.

"What are you doing?" he asked. "I can't keep my fangs away. You're forcing me into this."

He touched my cheek with the back of his hand.

"Hey now," I said. "Are you out to destroy your wife?"

"That's pretty far out," he said. "I tend not to do things like that. But things for me are getting a little hot."

His hand fumbled at my throat and his breath became uneven.

"I'm ready to explode. Where are you hiding your ignition?" I asked.

"Are you out to destroy your wife?" he asked and groaned. "Should we commit double murder?"

I called Vita's name. The woman was an idea that slipped between my fingers. His hands were around my neck. His mouth was insatiable.

"You're burning, you're so burning hot," he mumbled and struggled with his jacket. "Can I see you again?"

Vita sat at the kitchen table working on a sketch far, far away.

"During the week? Soon, at least?"

She lifted her head and looked at me, both near and distant in her thoughts.

"What do I get out of it?" I asked.

"A crime of passion," he said.

I told Vita that if she was meeting up with Hilde and Eva anyway, at least they could stop by an exhibit on Overgaden that I was part of.

"No, I don't think so, Justine," she said.

"What do you mean?" I asked. "That exhibit is all about space. That's what you're all interested in, right?"

"Yes, of course, but . . . We'll see it another time."

She said it was infuriating that the curators hadn't included any sculptors, even though that wasn't actually the case. The sculptors had built a kind of library: a social sculpture where you could exchange books. I'd placed a couple of books on the shelves myself.

She was meeting the others on Saturday. Vita turned, waved a gloved hand, and looked like someone from a farewell scene in a movie. She was running late.

Hilde's boyfriend, on the other hand, was breathlessly on time. He'd run the whole way from the bus station. He stopped at the door.

"Okay?" he said.

"If it's not, it doesn't matter," I said.

"No, there's no problem. You look great."

"I'm not interested, I think."

"Is that why you've put on the armor?"

"You're calling my skin an armor?"

"Can I touch you?"

"You can hold me," I said and turned.

Hilde's boyfriend, Finn was his name, took a couple steps back.
"I . . ."
"Touch my ass," I said.
"But you're all shiny."
"It's just grease."
"Why did you smear it on your ass?"
"Are you going to or not?"
"Hell yes, I will. I definitely will."
"Then touch me."
He reached his hand out and touched me with a finger or two, maybe three.
"Slap me," I said.
"Like this?"
"Yes. Feel how it stings your fingers? That's the oil."
"Or this?"
"Oh—that's good."
"Want more? Like this?"
I turned around. He was standing very close with eyes no longer brown but purple. His upper lip had curled, revealing his teeth.
"Come here, you . . ." he said.
"Dog."
"Can I take you from behind?"
"I'm glad you asked. Won't you ask nicely, though?"
"Pretty please?"
"Use your teeth."
"Here."
"Where it's soft, yeah. You like that?"

Vita, you're beautiful up there, beautiful as a twinkling star that falls and drifts, beautiful when you make me visible. You encircle my waist and crush my breasts. You say:

"We're an odd synthesis. Two interlocking pieces."

Could be it's the part about interlocking that confuses me. I also think we're two pieces. We're a whole puzzle that's been cast into the air and caught in the box.

"The energy that surrounds you penetrates everything," you say.

You like observing me from a distance. You. The bitch. Vita. Intimacy's epicenter. Lying there fiddling with your earlobe and following the drooping arch of your breasts with a finger. You drift silently and gently on the soft wind from me that blows and blows, almost imperceptibly, I'm the wind in your sail. You've assumed a different tone, a different color, a different form. Lying there fiddling with your earlobe. Watching you roll onto your side and wake. One gliding motion and you're gone from sight.

Nine

B ack when Grandpa was, he worked steadily in the house, back
and forth between the armchair and the canvas. He hardly
looked up when I came in, but his paintbrush made an elaborate
arc.

"Have I told you about value scales?" he asked, blinking at me.

Of course he had, and he'd also told me about highlights and
complementary colors, red changing to purple and so forth.

"You can use it in your own work sometime, you know," he said,
placing a purple simultaneous contrast near the yellow.

I sat down and opened my computer. Grandpa worked his spatu-
la around the painting with a squelching sound. Then he evidently
changed his mind and went out into the yard and stood there look-
ing around.

"Dum-da-dum-da-dej, rains a-coming," he said.

"It's clearing up," I said.

"It's going to rain, my child. It's going to rain."

Grandpa came in again and put some wood on the stove, one,
two, three pieces and some kindling.

"I'm your child," I said.

The old man with the paint-splattered clothes stopped. He turned
and looked at me.

"You are my child," he said. "No, you're not. I've never had a
child like you. Like hell I have."

Grandpa returned to the easel and found his spatula.

"Your mother," he said, "she's my child. No, poppycock. She's no longer a child. Even if one could say she acts that way. But damn it, she's not anymore. Or what do I know. I've got no idea how she acts where she's at now. How would I know that? Your mother is my child. No, there I go saying it again. She was my child. That's what I meant to say. Was. She was nothing like you, my girl. Of course, I just said my girl, but you know what I mean. Don't you? Yes, sure you do. She was a sweet girl. She was a very, very sweet girl. A little sugar. You should've heard her voice. Crisp as a tiny bell. And she could say the sweetest things. She called me papa. She sure did. Who would've known what was hiding inside? It was nothing on the surface, that's for sure. As captivating as she was—but her temper, let me tell you. She had a terrible temper that surfaced from time to time. Yes, there certainly was a difference between what was on the inside and what was on the outside. That we learned. Not immediately. No, it became apparent with time. Once you made her mad, though, and that certainly happened, you couldn't make it right again. She could stomp around for days on end. Yes, indeed. You yourself know how it was. That was more than just a couple of days, though. That was several years. More than a few years went by. But when she was small, it wasn't so bad. Even if it was bad enough. One time I got her a bag of sunflower seeds. I don't remember where I got them from, but I had them. They made her so happy. She shelled and shelled and ate as many of them as she could. The rest she planted in the garden. Right over there. Next to the spot where the shed used to be. Yes, right there. She'd be a gardener, that's what the little thing said. She was so diligent and watered and watered. Every day she watered them. And one day, luckily, the seeds began to sprout. Otherwise, she would've been so disappointed. And they grew. Your mother was so proud. She was a soldier, that child. You can almost picture her there, how

she sat watching over those little seedlings. Just think, some hungry snail might come by. Ah, me. After a while, she had a whole little forest growing there. Unfortunately, it didn't end so well. You probably don't know about it. In any case, I haven't told you. Probably not your father either. Or has he? He doesn't understand shit about what happened, the ignorant son of a bitch, and by God, he never has. He didn't give a damn about it, he didn't give a damn about it at all. The thing with the flowers ended in a terrible uproar. Yes, not with your mother, but with your grandmother. Oh, I'd nearly forgotten it. The evening your grandmother went out into the garden. For some reason or other, she went into your mother's flowerbed. And you know, there they stood. Thirty big sunflowers with their yellow heads. And she got the crazy idea that the devil himself had sent his eyes growing out of the ground to spy on her. She moaned and shrieked. What a spectacle she made. I couldn't calm her down again. She just couldn't let go of that insane idea. I was forced to cut down the whole mess and burn them before she'd simmer down again. You can imagine how your mother took it. Not well. Not well. She was so unhappy. First she threw a fit. Then she didn't speak a word for several weeks."

Grandpa settled into the armchair and leaned his head back.

"Ah, me," he said.

"Is it also true what my dad said, about how she thought there were worms in my mother's hair?"

"Oh yeah, that story. No, she didn't have it easy. It was never good again. But you know that for yourself."

"I do?"

"She wouldn't come home again," he said. "She simply refused to let me help her."

"I don't think you could've helped her, Grandpa."

"A little more than I did, anyway, I could've done. But she wouldn't have it."

"No, she wouldn't."

"And now it's too late."

"Yes."

"My sweet child."

It's strange and a law of sorts that one can't go back to what was. Now that I've sent it all packing, there's just empty space and a bunch of indeterminate whatever.

I'm an artist without a work—but then am I really an artist?

Now I think if only I had Grandpa's painting to turn to . . . I think: If only I were Grandpa, or some other painter, safely anchored in the notion that everything can be formulated in painted reality. Now I'm wondering what I actually know about painting, or about painters, for that matter? And now something is knocking on memory's door, and in waltzes the memory of Grandpa's paintbrushes and pallet, and the paintings I painted, and Ane glancing up from the easel with absent eyes, completely lost in her painted world. Present there is also Ane's friend, Lord preserve us, Randi, with her breasts, huge, yes, enormous, yes, vulgar, but in no way sensual. Could it be that I also want to be Randi? It's something of a thought experiment, everything would be so easy, or so I think, but what do I know about Randi and what it's like to be her? Would it make things easier? Simpler? Randi might potentially be a good object, she might replace me for a time, but I'd never be like her, so no, it's doomed to failure. Not because of her breasts—it just wouldn't work.

Randi works for a private hospital north of Copenhagen. Ane has known her since they were kids in Jutland, where the sun always shone and the world was a breeze.

"What's great is that it's actually wonderful having a friend who's not an artist," Ane said and invited both of us to her place one Friday evening.

She was a tall, attractive girl, Randi, with a huge chest and narrow waist. She found my name amusing.

"Depends on how you look at it," I said.

At the table we all sat across from each other. Randi said that she was an anesthetic nurse at Højen.

"They do all sorts of operations," Ane said. "Breasts, liposuction, face lifts, lips and . . ."

"So do tons of women come to you for cunt jobs to make them look nice?" I asked.

"Tons and tons. Some do come, yes," said Randi, "and we call it a vagina."

"I'm sure I'd be willing to have something done if my body changes too much after I've given birth," Ane said.

Her eyes told me to behave.

"Plenty of women do that," said Randi. "We just helped a girl whose baby would only nurse at one breast. Not like that's big deal. But it meant that when she stopped nursing, you know, one breast was a lot longer than the other. As you can imagine, she wasn't too happy with that. In any case, I wouldn't be. But she came to us and

got her breasts done. And now you can't tell the difference between them."

"Wow, that was lucky," I said.

"If I ever needed it, I'm sure they've gotten so good at breast jobs that you can't even tell," Ane said.

"Absolutely," Randi said. "We're really good at it now. But we're always getting better and better."

"The best is yet to come," I said.

But then Randi said that she herself had had a boob job. There was nothing wrong with what she'd had before, she just wanted something bigger. Randi pulled up her tight blouse to reveal a white-lace bra with huge cups that she opened with a twist at the back, and out popped two perfectly round breasts. I stared into the red eyes of her nipples.

"Where did they insert them?" Ane asked, leaning forward.

"Right here under the areola," Randi said and pointed at the underside.

"And there's no mark?" Ane asked.

"No, huh? You can touch it if you like," Randi said.

Ane pressed a finger to one arch. The breast gave elastically.

"It feels totally real?" Ane said.

We were done eating, and I stared at Randi's breasts beneath her blouse, two springy domes. Randi crossed her arms over her chest and pressed them together. Ane changed the candles in the sticks. Randi and her breasts leaned back in the chair. Ane pulled up her jacket to reveal breasts that were pale and distended and full of mammary glands. Randi lay down on the couch. Ane talked. Randi's breasts poked up like two domes in the air. If she stood on her head with those breasts, then what?

But then it was time for Randi to go, because the next day she had the morning shift. In the entryway everyone's breasts got squeezed together, and suddenly my hands reached out and stroked

up Randi's body to reach the domes from below. They were firm, they were yielding, they were heavy, they were warm. The face over the breasts became white, white turning red. Then Randi ripped her breasts from my hands and said goodbye and good night.

"Why should you stand there groping her breasts?" Ane asked after the door had been slammed. "You think they're disgusting, right."

"They were enormous," I said. "They were simply enormous. They were pure art."

Not too long after the dinner with Randi, Ane returned giddy from a weekend trip to London. They'd been traveling together, they'd visited boutiques and cafes, "and Randi has got us an exhibit at her clinic's art society," she said.

It had been a long time since Ane had exhibited anything, and she thought it might be fun to do a small show with some drawings or paintings at Randi's workplace.

"It's an art society, Ane," I said.

"Yeah, so what?" she asked.

"So it's not serious, that's all."

"I'm well aware of that," said Ane. "But if we get to paint some paintings and we make a little money in the process, who cares?"

"I'm not a painter."

"So? You'll paint anyway. You probably learned loads of stuff from your grandfather."

"But has Randi seen any of your paintings?"

"No."

"Then how does she know that they'd like to hang them?"

"Come on, Justine, let's just do it for shits and grins. Let's make some money for once?" Ane said.

I said: "Yes. Yes, let's do it. Let's have some fun." I'd also like to be close to Grandpa, after all. Or what was left of him.

Around the same time, Vita was working on a monument to a dead physicist. Her idea was to give his groundbreaking theories three dimensional form, so they'd unfold and intertwine into a single mirror-smooth object. In addition to that project she'd received another commission, a decoration for the Holmen Operahuset.

"How great that we're both so busy," she said. "Shouldn't you figure out what you're doing for your X-Room exhibition soon?"

"It's fine," I said. "I have all the time I'll need."

Vita continued working on her drawing; she looked like cells in a state of controlled reproduction.

"I've been thinking about it," she said, "shouldn't you just keep working with that sculptural idea? You have such a refined spatial sense. I still kick myself for not buying your ice floes that time. But I just didn't know where I was going to put them."

"I didn't have the space either. That's why I gave them away."

"So you've said."

"They look good where they're at now."

"You could just give it a try, you know," she said. "You could always go back to what you usually do after that. No one is saying you have to do sculpture all the time."

"I'd rather do this," I said. "I have an idea for something I want to try out."

Suddenly, I was extremely grateful to Ane for coming with Randi's offer.

We decided we'd paint together out in the garden and not spend a krone on supplies. We still had Grandpa's big box of colors, after all. Some of the tubes were dried out, but most were usable as they lay in rainbow array with Grandpa's large fingerprints on the lids and labels. We also found his old pallet hiding behind a bookcase. Ane used a glass scraper to get the paint off. She was wearing one of the smocks that could still close around her belly. As she sweated the paint flew like bits of lint around her.

We painted and painted. Ane painted still lifes and the organisms leaped from the canvas. She found her themes in the garden. Even though it was only approaching spring with snowdrops and winter aconite, everything in Ane's paintings overgrew itself. Apple trees blossomed, stamens became long tongues and petals swelled to sails.

I sketched my themes with Grandpa's charcoals. The sketch, Grandpa used to say, the sketch is not just a prelude, it's the actual skeleton, supple and full of energy and immediacy. What you cover it with is ooze, and it's a helluva job to transform that ooze into flesh in order to get down to the skeleton again.

I saw the painting's skeleton there before me and prepared the pallet with zinc white and ocher and umber. The base was a composition of cold and warm tones, just as I'd been taught. Then came the shadows and highlights and layer after layer of nuances. And then came the longdrawn decomposition, the honing and the tightening.

Vita stopped by and looked over our shoulders, she chatted and was content. Ane suggested that she join the exhibit with some small sized objects, something that would fit the architecture. Vita thought that sounded exciting. Randi also came by. She thought Ane's paintings were insanely beautiful, she said, and she was looking forward to showing them to the other people at work.

Ane's paintings would hang first and then mine. At the opening Ane sold every single one. It was a Friday afternoon just before closing, the art society's president gave a speech and toasted Ane for her unbelievably animate pictures. Ane thanked him. She had on a light purple dress and red Mao shoes with a big colorful scarf wrapped around her hair. With her little belly, she resembled one of her own paintings. Drinks and praise circulated, and then began the sale of the paintings. Right off the president reserved three paintings for himself, and the rest went quickly. Red dots appeared, soon the twenty small paintings' future pathways out into the world were framed.

The following month it was my turn to hang paintings, but now I was in the middle of something else and had forgotten that I was Grandpa the Painter. My house and garden had been transformed into a working studio where the settlement for the X-Room was taking shape.

Ane was upset. She didn't know how she was going to tell to Randi that I didn't want to exhibit after all. I didn't know how I should explain to Ane that I'd just wanted to be Grandpa, and that

I felt I'd succeeded for a small instant, and that that was enough in itself; I never wanted to be something other or different than the me I now once was. Ane was upset that she was the reason that the clinic's walls would remain empty. I suggested that she should keep her own paintings on display, but she didn't want to. So I went ahead and hung the pictures.

Vita went to the opening. She wanted to see the clinic and its particular architecture. I thought: Hell, this is a snoozefest, no one understands the paintings, not even me. They weren't especially good. I sold two to the art society's president, but he was almost obliged to purchase them.

The exhibit hung for two weeks until Ane came home and repeated what Randi had said, what I already knew anyway, that no one understood the pictures. If only they'd been attractive or in some other way agreeable to look at. I went out and took them down one Monday afternoon. The woman behind the counter got a strange look on her face when I began cutting the lines.

"There's been a misunderstanding," I said. "I'm really sorry."

Ten

The armoire was drunk with memory, and now it's burned to-gether with everything it held. Flakes of remembrance float in the air, cast about in the stream, disperse, collect, settle on skin and in hair that's cut short. The armoire was full of shit, that's what it was, full of old shit. Truth be told, I couldn't stand that armoire, not even now when it's been razed to the ground. Now it just fills up even more. All that was forgotten, is.

In her armoire, a blue armoire she never came and collected, there were three photographs. I inherited it from Grandpa, a farmhand's armoire with a large red poppy on the door that hung askew, it didn't close tight. In one of the pictures she was small, she was sitting on the handlebars of a bike, Grandpa's, with a bonnet and round cheeks. In another picture she was young, fifteen years old, I think, with a fine hairdo, the kind they wore back then. In the last picture she was together with my father, they'd just gotten married, my father, my mother, my father looking handsome in his suit, she in a very short dress and knee-high boots, they looked so happy and in love, and they were, Grandpa said, so in love, inseparable. She was the most beautiful girl in the whole wide world.

When I stood to the side and studied my reflection in a second mirror, I thought that our noses were similar, we both had that kind of long, straight nose, and there was also a certain something about the mouth. "Yes, of course you're beautiful," Dad said, "you look just like yourself." The boy's body I inherited from him, the oversized feet, and also the hands, not too big, but bigger than the others', and the broad shoulders, those were his as well, he said, my father.

I sat inside the armoire with Mom, and her cheeks were bright red in the pictures; there was also a likeness about the eyes, the way they slanted down toward our ears. Whatever she was inside, that's what she was inside the armoire. If I stretched my arms out, I could touch around me everywhere and the world on all sides,

see me, see me in the dark, and she touched me with her pupils, fondled and touched, "it's fine, everything is good in here, I exist, therefore you exist," "why aren't you in here then, out there, where are you?" "it doesn't matter, everything already is," "you need to be here now, inside, not outside," "I'm here," "where?", "here inside you," "but I don't want you like that," "it's already like that, my sweet, there's nothing to be done," "but I want you here."

"Is it true what he says, that my mother was drunk the entire time, why was she like that, and was it really like that?" Grandpa dropped the bag, egg whites splattered across the floor, yolk too, yellow on the ground, "oh, for fuck's sake," he said, "nothing to be done about it, so what did he say, your father?" "just forget it, he didn't say anything, it doesn't matter," "no, what did he say, he said your mother was drunk, that she was drunk the whole time, is that what he said?" "just forget it, I didn't mean anything by it, I was just talking to myself, it's not important," "yes, it's important, and now you tell me exactly what he said, you tell me right now," "no, Grandpa, stop, ow, that hurts, let me go, I said it was nothing, let me go, I'll yell for Dad," "go ahead and shout for the S. O. B, but by Satan you'd better shout loud, he doesn't know how to help, anyway, if you think that, if there's something he can't figure out, the idiot, it's how to help a woman in need, no, my girl, I tell you what, you can't count on him, he's only out to save his own skin, that's all he's ever done, by God, argh, the big ass, what did I ever do to deserve such an impossible son-in-law, gah, for fuck's sake!"

Grandma was dead, she died quietly and peacefully, nothing to be done, that's how it should be; it was also for the best, she hadn't been doing well. She was buried next to the church. My mother was supposed to come, but never showed, nothing to be done, no one had really expected it, I wasn't doing too well, my stomach was tense somehow, but in a way I was also doing okay, even though I'd like to have seen her, it was nice that she wasn't there, nothing to manage. I was with my father, I said that we'd better hurry up, yes, we'd better, it was getting late, we arrived just as the doors were closing, the music was audible out on the steps. Dad opened the door to the church, there weren't many people inside, just a bunch of empty pews, though way up at the front there were a couple of people after all; I couldn't find Grandpa. Dad said that we should sit in the back, so we sat on a long pew in the corner right beneath the candles, the light dripped, down the stick, down the wood. On the pew in front of us there was no candle, but a small flower instead, and so they alternated, candle, flower, candle, flower, candle, flower, candle, flower, all the way up to Grandpa who was sitting way up front, I'd caught sight of him, his hair stuck up over the pew back, it was him, no mistaking it. The music stopped, no one was singing along anyway, aside from the priest and Grandpa and a couple of the others, I didn't know who they were. The priest began his sermon, loud in the church, Grandpa's head lifted, he turned around and looked back at me, his face said: Come up here. My father had folded his hands, he didn't

see Grandpa, or perhaps he did, I don't know, but he looked at me and said: You can go up there, I'm staying put. He said it with his eyes and jerked his head toward the casket in the aisle in front of the priest, white with flowers on top, light red roses, I believe. I couldn't stand up, no matter, suddenly the whole thing was over, and then I could stand and walk down the aisle toward the door, we waited outside, Grandpa emerged with the casket along with a couple of other men. We were also in a hurry, we were going to the swimming pool, but we said goodbye to Grandpa, small beside the casket, she was within, no doubt, with hands folded across her chest, isn't that how they lie? Folded hands and closed eyes, just like she used to sit in the chair back home watching things unseen or TV, and she'd fallen asleep in that chair, Grandpa had found her, but by then it was too late, he'd been down in the basement, it was over, nothing to be done, and that was also for the best. Grandpa didn't cry, but in some way he was probably sorry. The casket was enormous! Hauled away in a trailer with windows so we could see the roses lying on the cover, a ribbon and a wreath, and then the car drove away, Dad clapped Grandpa on the shoulder: It'll be okay, you'll see, the best that could happen, how great that she should just happen to fall asleep like that, so quick and painless. How did he know it was painless? No clue, but Grandpa looked as if he wasn't listening, he just sank together and became a point on the gravel path.

Grandpa said that Dad was so busy playing smarty-pants at the university that he didn't have the time to take care of her, getting clever was much more important, oh so clever, and what in the world did he need all that knowledge for, his head just ballooning and getting bigger and bigger until it was no use to anyone? A complete waste of time, nothing that benefited my mother certainly, she'd needed him, that's right, she'd needed help, he'd been too busy to see it, he simply didn't get it, right there before his eyes, like that! Unfortunately, I've got some work for the department, Grandpa said in a voice that was supposed to be Dad's, sorry, I've got no damn time. So she got tired of it, he thought only of himself when she gave birth to me, how could she make him understand that becoming a mother wasn't easy?

In some way Grandpa did blame my dad, but whose fault was it really? Simply take the blame and let it wander from the one to the other, I didn't know what to believe, they said so much, all of them, Dad, Grandpa, well, there were just the two, but they did talk about it often. And what about Grandma? It was undoubtedly wrong that she just sat at home, she never went out, and did a doctor ever come visit her, did she ever go see the doctor, did anyone actually even know what was wrong with her? How should I know, I wasn't a doctor, Grandpa probably knew what he was doing, he was pretty smart, in any case, he was a good man, and that was more than you can say of so many others.

She stood at the train station with her hands in her pockets, was it her, was it not? Visiting her had been my idea, this lady with the skinny legs, the knees bulging beneath her pants, would she be wearing a yellow jacket, would she still have those pants on, is a mother more substantial than the lady or the woman? What's the difference really between a woman, a mother, a lady, and a person of her age? She fit the lie, they'd all lied, he wasn't trustworthy and he knew exactly what he wanted me to believe, about her, too. There she stood.

"You've gotten so tall and beautiful," she cried, she laughed, "just think, Mommy's little girl has gotten so big." Would she smell like that? No, she wouldn't. Or rather, yes. "Hi Mom," I'm not a little girl, I wanted to say, but didn't say it. Would the gaping hole of her mouth be missing a tooth? Would she have wrinkles, black in the crease upon crease of her upper lip, just like the man at the pub? Her nose wasn't straight. She had curly, short gray hair, she smelled, and with that we took the bus.

A woman she wasn't. It was hard to say why exactly, she just wasn't. There was nothing feminine about her, like her very sex had vanished, had shriveled to dangling skinflaps, her breasts to hanging bags, skinny, lanky, slack. She was porous, shaky, with yellow nails and with a voice that grated unevenly, and the various cardboard wine boxes that leaked and ringed the table, red, blue, purple.

When she returned home that morning, she had an entirely different odor, rather bland but nonetheless sharp, a mixture of grease and skin and hair, somehow gray, something that was dry and waxy, that flaked and caked off. The smell stuck in your nose, full of a heaviness that bored its way into your nostrils, swirled around your hair and up to your brain, swirled dismally, then down your throat into your lungs, penetrating your every cell and settling like fat around your heart, more dismal still. When one hasn't bathed in a long, long time, it smells like that.

And liquid splattered the linoleum in the kitchen through the hall and into the bathroom, on the tiles, splish and splash, and finally on the sink's porcelain, a clump here: She'd eaten something after all.

And the buttocks that were nearly gone, just two hollows, the skin almost drawn away, sunk down, hanging in strips beneath the gray, brown pimpled skin of her ass, would come off in layers, stinking of cessation that stretched to eternal suspension, time that stalled or dropped into the bowl along with the rest of the liquid and cough, cough, void, completely devoid of hours.

And still. No nasal sounds even, no snoring or mumbling or tossing, just silence and the body, quiet as a mouse beneath the covers, a quiet little mouse.

And while it lasted: My pants that almost became one with the chair, an adhesive bond that you neither would nor could, yes,

SHOULD break. The silence was so still and eternal, and that was good somehow, because at least then nothing was happening.

I heard her fumble with the key in the door, now she was finally home, sneaking past the room where I lay, the yellow jacket coughed and laughed at something, the grumble of a zipper, and then the door to her room closed, silence. I saw by the clock it was four thirty. And woke again, a smell in the room, I couldn't figure out what it was, smoke crept through the crack above the door, and I sprang off the couch, we were on the eighth floor, and ran to the window, ran to the door, a voice called, took my pillow, held it before my face, opened the door was full of smoke perspiration, redolence and skin, couldn't see her, away in the smoke, small flames on her coverlet, and smoke crawling up the walls, fire creatures and trolls with pointy hats crowding under the ceiling, a blanket, ran into the kitchen, her voice that called from the eighth floor, ran back to my mother, fire, fire, fire on her clothes, pulled and heaved, out of the room my head roaring at the door firemen, masks, suits, my mother and me, carry me, carry me, and cars on the street.

My father sat at the bedside and mumbled, "oooh, ohhh, ahhh," he said, not another sound, he looked up at me, "oooh, ahhh," and then he wept.

Something that both ticked and dripped, she lay in another room like a lady packed in white with wild red eyes, a ghost because she'd fallen asleep, now her lashes bubbled, resembled live lava. She'd set fire to her coverlet. It was her own fault. That she'd melted.

"I'm a huge idiot," said my father, "what have I done? What was I thinking?" nothing, "we'd be better off if she was , her life is not , it never has been, it's always been a life full of , I can't take any more, no, no more now."

I didn't think , and the silence that dripped and bleeped with a small blip, blip was as it should be, on the brink of nothing, just the red in the white and soon to be no more dripskin in tatters with ruffles, it .

And the body. They bore her body out, we weren't allowed to watch, it wasn't pleasant, the dressings were bright red, wet, and one of her breasts was burnt off along with a portion of her underarm, like a muscle perhaps, an overdone roast, coal. What do you call a breast, anyway, once it's been burned? Not a word from her, and suddenly she was gone, out of bed and out of sight, away, away, away, infection, and then she was burning again.

Here's what filled the armoire: memory's cremated bones.

Eleven

My bed is wet. I'm splashing in water with my head full of memory loss, all those memories I left on Kluden's floor, and it feels simply wonderful, weightless. Now I meet ground. My legs are still floating in water. I pull them in and stand.

I'm staying at Hotel I'm Someone Else. Noted, and so what? The me who's at this hotel likes that the old, warped, panel door hangs ajar, and has stopped trying to close it. There are people in the hall walking back and forth, going out, in, passing the gap in the door, there's flickering light and sounds that rise and fall. Right now I'm here. In a moment I'll be at The Factory.

Here's The Factory. I'm inside. A moment ago I was outside. I took pictures in front of the container, I was a workman, a graffiti artist, an addict, I was someone who fell and busted a knee.

Trine Markhøj has relocated to the hall and has cleared a space, obviously she's starting a new project. For the moment it's just a long iron skeleton wrapped in chicken wire, a diagonal pattern in space. Four young men are helping her out, they slap clay onto the skeleton, hum, gossip about who got into the academy this year. Two of them applied, but didn't make it. Next year they'll try again, they say, and in the meantime they're working here, and here is where I am, and there's Trine Markhøj.

"Hooray!" she shouts. "Hooray! Hooray! We're finally starting."

She dries her hands on her pants and takes out a drawing that she unfolds, a sketch of something that resembles a piece of excrement.

"A sausage," says Trine.

"A sausage?"

"Something like that. It'll be thirteen meters long with the amount of clay we're using," Trine says and disappears.

I disappear too, or rather: I'm right here inside the studio. The door hardly closes thanks to the enormous brown bolster expanding and dividing and creeping down the corridors, or so it seems, and the camera is out of batteries. Shit. There won't be too many pictures anyway, because my eye is itching again, though it has also left me in peace for a couple of days. I've simply got to get out of here.

I'm wearing a patch, somehow the darkness and the pressure help, fortunately the air is clear, my destination not too far, the hotel is close, but what's happening here? The small plaza is frothing with people, they're all flowing down the street in the same direction.

It's got to be Bo. He said the soup kitchen was up and running, today they're setting up the area. Come by, he said, but I declined, and now it's nearly impossible to avoid turning up, one is simply swept along to the street kitchen that's been put up on the plaza behind the hedge, boiling pots await people standing around in clusters, skinny jeans, hoodies, it looks like the whole academy has turned out, not to mention a bunch of others, bicycle wagons packed with kids mingle with old strollers, raccoon tails, uniforms, and layer upon layer of plastic bags.

There's Bo standing with a girl who introduces herself as Åsa. She's busy unpacking paper plates and towels. She holds out her hand and smiles with an open face, blonde hair and a nose ring, the clink and chatter of multiple bracelets. Bo is tending the pot on the burner, tomato sauce, Åsa laughs the entire time, she shouts in Swedish that she'll grab the bread. There's a motorcycle cop on Dybbølsgade.

I drink a beer. Here I am leaning against the wall, right on the brink, can anyone see me? I recognize every one of you this warm evening, and man, am I exhausted. You laugh and talk, I'm blue becoming violet turning dark, like the sky. Now you're headed off to Kluden, I could go with you, but don't bother.

I grab a bottle of rum from a kiosk, and dub the bottle Haddock. The name fits the patch sitting snug against my eye hardly even irritated. We wander along the bridge and hunker down on the wharf, just Haddock and me. We look at the water. Out across the harbor. People in silhouette. We kiss, a long sloppy kiss, kiss we, it burns. Then we take a walk along the water, across the bridge, and out onto Amager Fælled, the nature park. Here everything is topsy-turvy. Out of the twilight emerge four, five large tents and a row of baby carriages, next to them sits a woman who's incapable of standing, she's totally drunk and has puked down one of her pants' legs. Beneath a tent canopy a group sits shouting around a table. A heavily bearded guy yells he couldn't fucking care less, a woman shouts that, fuck, she's there too. I step on what's left of a garden torch. I can't figure anything out, and at present Haddock isn't much help, the place reeks strongly of piss, and over there a woman is striding over a garbage sack that's burst open on the grass, she's intent on joining the others, nothing else matters, she knocks into a skinny guy who's also striding along complaining that his tent collapsed, someone sliced holes in the canvas, he shouts, they also tried to set it ablaze, and no one at the table understands a thing. The tall man performs several high knee-lifts and jogs on, "Damn, that's far out," mumbles the lady in the grass, who's lying completely prone now. "Totally way out," I tell Haddock and look at my feet. We've left the path, somehow or other we've wandered a ways into Amager Fælled, on the horizon I can see Ørestaden, and the path must be

around here somewhere. And indeed, there it is, right there. It was just crouching in some bushes. Now I'll just follow it back to The Factory, I'll even snap a couple of self-portraits before calling a taxi.

They crowd around me, no matter where in the city I go, it's entirely unprovoked, they shove forward, trying to get a look, here comes Hans Duns, the . . . He just resigned as professor at the academy of arts, right after our Kassel trip in the spring, and now he's getting younger and younger, soon he'll start his basic training over again.

Oh, no, he's coming over, shit, shit, shit.

"What did you do to your eye?" he asks.

"Nothing."

"One of your eyes is all red, did you know that?"

"Yeah, something to that effect."

Duns laughs and claps me on the shoulder. Clearly, he knows what I'm about.

"You've always been something special. When are you finishing up at the school?"

"Next year."

"Tight. I was wondered if you'd like to have a peek in the gallery at some point? I have an exhibition. The whole thing's already sold beforehand."

Hans Duns laughs and slaps my shoulder again. This can't go on, we're not comrades, or are we? How intimate does he think we are?

"We should also figure out something about a performance."

"I don't perform anymore."

"Really? Since when?"

"I sculpt."

"Oh yeah, fuck, you're together with Vita Laura. She's quite accomplished, isn't she."

"Yes."

"What's she doing lately? Is she still working on the stuff for the opera?"

"Yes."

"Hey, here come Asgar and Torben. Hey, you two!"

Yes, it's high time to hightail it, because there's Torben, and him I can't take right now.

The exhibition arena was a writhing human body the day Documenta opened to the public. There were press viewings the days prior, and many well known artists had stuck around. They circulated among us.

Ane and I were there with Duns's department. Gretha Müller had gotten sick and couldn't travel, a plus for us, Duns said, drawing us along, a rooster in his element.

"It's time for you to start networking," he said. "That's what you've got to do if you really want to get somewhere. I did the same thing when I was at the academy."

"What did you do?" one of the other students asked.

"Went to openings with people I hadn't met before. You've got to be pushy, that's the trick. That's the only reason I have so many contacts all around the globe. I'm pushy."

We stayed in a hotel on the edge of the exhibition arena. Ane and I shared a room. Ane, who didn't want to miss out on the breakfast buffet, went down to the restaurant with the others. By the time I got up, the day's program had already started, and I saw the others hurrying through the exhibitions behind Duns, who pointed out important things.

That evening we sat in a pub and ate sausage and sauerkraut. Duns was generally satisfied and bought a round of beer.

"Did you all see the videos hanging up by the ceiling in the long hallway?" I asked. "They're totally fantastic. You all should go

down and see them. They were made by some Inuits in Canada. They made a whole TV series about life back in the old days."

"I hadn't heard anything about those videos," Duns said.

It disturbed him, I could tell, that something was out of his control. "Strange. Where did you say they were?"

We rotated places so that Duns could sit next to me.

"It's very interesting the way you use yourself in your work," he said. "Why don't you just take the final step and give a live performance?"

"I've done that plenty of times," I said.

"I'm having an exhibition in my gallery in the fall. Couldn't you come and do something in that context? Something crazy?" he asked.

"I don't know," I said. "It depends on what the subject matter is."

"I loved the video that got you into the academy. You had my vote immediately."

"Many thanks."

"None of that, damn it . . . it was good. Because it was so wild. So direct . . ."

I pondered the meaning of wild. Ane, who had joined us, threw me a look asking if I knew where this was going. I sent her a look back that said: Keep your pants on.

After the pub closed, we headed to the massive opening party at the train station. Duns tried to dispatch the boys in the direction of a couple of big named artists who stood talking in a crowd. They passed the bar on the way and grabbed more beers instead. It didn't take long for the group to fall apart. Duns's whole demeanor said that we were a bunch of wet blankets, but he walked us home.

We sat and chatted in the hotel lounge; a couple of people headed up to their rooms to keep drinking, I wanted to go to bed. Ane decided to hang out for once, even though she was pregnant. Duns overtook me at the elevator.

"I was heading up to watch some TV," he said. "Do you want to watch something together? I have a bottle of whiskey. I bet we can get some ice at the bar."

He had a large seventh-floor room with a view of the exhibition arena. People were still out on the square beneath the street lamps, I saw, pulling the curtains wide so the night could stretch out on Duns's king-size double bed. Behind me the toilet bowl resounded, Duns's was clearly no cautious rim-pisser. The next moment he stood in the room with two glasses and some crackling ice.

"Cheers!"

The bed pillows were enormous. Duns watched while I drank my whiskey. Then he smiled with his overly small and yellow teeth.

"I smoke forty cigarettes a day and drink four liters of cola, and I'm addicted to whiskey," he said, draining his glass.

He positioned himself at the open window and lit a cigarette.

A song by Radiohead was playing on the TV, which hung from the ceiling. Duns took his clothes off and sat on the edge of the bed so he could see the screen. Then he turned toward me and touched my nose with his index finger, it smelled of nicotine. I wondered if his dick was shrunken and coiled in his underwear or whether it had unfolded. They played yet another Radiohead number. Duns lay flat on his back and watched TV.

I fell asleep next to the professor. At some point, I woke up and removed my pants and jacket. The next morning I flashed him my breasts while I was dressing. I took my sweet time. We rode the elevator down to breakfast and went to our separate tables.

When I came back to the room, Ane was still asleep.

"Where have you been?" she mumbled.

"I'm a creep," I said.

"If you were with him, then yes."

He was so beautiful lying there in the bed, spilling tautly out. His haunches, with his leg and foot thrown out to the side, while like a small bird on the nest: his cock.

"Don't you want to take off your clothes?" he asked.

"I will," I said.

"So do it. Take them off."

"Okay."

"Shall I help?"

He rose onto his elbows.

"You should lie down," I said, pushing him back onto the mattress with a foot.

"So we're not messing around, huh?" he said.

"No, we are," I said. "That's all we're doing. Look what I can do."

I towered above him. He was a vaulted landscape below, his chest two hills that heaved-sank, heaved-sank, his eyes twin black pools.

I pulled my pants off.

"Can you see?"

"I can see your cunt."

"How does it look?"

I parted the banks and let my finger glide along the river. Smooth.

"I want to touch it."

"You will."

"Can I?"

I put my foot on his face, the heel in his mouth, crushed his nose beneath the arch.

"No."

"Do you know what you're doing?" he asked.

"Your dick is hard," I said and turned around.

"I can see your ass."

"Can you?"

I parted the hills, let my fingers wander along the cleft, land in the grotto's ring, enter.

"You like that?" I asked.

"I love it."

I sat my ass between the hills of his chest and took his bird into my mouth. He moaned and bucked and slapped me hard with a hand. He heaved and sank and tossed me. I grabbed him around the neck with his head on the mattress pressed my fingers in, into his eye sockets.

"Now you'll be all eyes."

"You're nuts."

"Yep."

"I'm coming."

"Yeah."

"I'm coming on your ass."

Twelve

It's totally confusing. I've been to Amager Fælled again and the tents are nowhere to be found, not a single cigarette butt, not a can, not even an old shoe. But here in Vita's kitchen the stench from the box of potatoes is spreading, the carrots have shriveled up like little old women, and what's even worse: Something's knocking on my cranial door, something wants in. Now!

It's no zombie, but memory coupled with red wine glasses standing provocatively on the table, broadcasting their significance to the room, I can't escape it, it's here:

It must've been just past midnight, it was dark anyway, and the allotment society slept, just a couple of the houses had their lights on. At Vita's, I leaned my bike against the hedgerow and saw another bike there, huh? Nothing to see, just a light in the kitchen window.

In the yard. The window was a movie screen on a dark wall, the light streamed across the ground, and there she was, Vita, on the couch. She was leaning back against the cushions with a glass, oh no, holding it by the stem. Next to her, almost on top of her, sat a . . . woman . . . a woman with short, bristling hair. The woman glanced from her book at Vita. The way she smiles in a loving way. Vita smiled back at the short-haired woman, beamed, opened her mouth, drank, her lips tightened, relaxed, smiled. The women caressed each other, up and down, up and down in sure strokes. They caressed. They kept on caressing.

Then the short-haired woman closed the book and drank Vita instead, who caressed, mouths moved, they kissed. They stood up, in sync they stood up from the couch and vanished from the picture, perhaps to the bathroom? Gone. The light from the window fell in a fan to the ground, then they returned, oh, no, oh, no, naked. The short-haired woman walked to the window, she leaned forward with huge, dangling breasts that bobbed, no, pitched from side to side like waterbags. She blew out the candles. When she filled her lungs, her breasts heaved from side to side . . . then all was dark.

I couldn't see in the dark and tripped over something and fell. It was a box, black, with a label on it, and then I recognized it. Vita and I had retrieved the box one evening when we'd wanted to watch my videos. They were all my recordings, all the mistakes and also the good minutes, everything that never amounted to anything, along with the things that actually did. It was embarrassment become amusement to watch those recordings with Vita. It was amusement become embarrassment to see that box in the night.

She's right, I really should get rid of this key, and how I do long to be rid of it. I'll never come here again, now that there's nothing to come for. The key is furious and almost too large, but I take a gulp and wash it down with tapwater, oww, it rends the whole way to my stomach.

The evening it burned, just a short time ago, she stopped by, yes, multiple people stopped by my house, people of importance, suspicious, one might say, if one was a detective, and a detective of sorts, that's me, hunting for a place of rest that perhaps doesn't exist.

Vita didn't want to talk. Actually, she wanted to leave again as quickly as possible. Her replies were curt, almost superficial.

"?"

"No."

"And what if?"

"Forget it."

"Couldn't we?"

"Not anymore."

"Never?"

"No."

"."

Not a single word about the short-haired woman.

When I suggested we grill up some sausages, she put down her half-full glass, she hadn't tasted the wine, which, by the way, was wonderful, a special kind of grape or something.

"I can't, Justine, I just can't keep up."

"Keep up with what? Is it because I want it, or is there something else I want that's a problem, or what is it you think I actually want?"

"It's nothing specific . . . or . . . it just doesn't fit. To be honest, there are a lot of specific things I just don't like. I'm just done, you need to understand that."

"Something I did?"

"Stop asking questions. We're way past the trivial. It's the whole thing part and parcel, and it's also just a decision. I think it's best for us both. I'm sure you'll be able to see that, perhaps not now, but . . . later."

Suddenly, there she was in the armoire, banging and protesting, she screamed so loudly, unable to break free, the blue wardrobe door vibrated, the key sprang from its lock and landed on the floor, chink.

"Just relax, you'll get out, I just need to take care of something," I shushed her.

Finally, it was quiet, just the sliding noise of a surrendering body and a deep sigh.

"You're sick, Justine," she said from inside the armoire. "You'll regret this."

I relaxed with my wine and sausages and was a sphincter and a whole mess of other things.

I grilled all my crap around ten that evening in the yard under the sky and saw Torben walking up. Was he here? Shit. How could I have forgotten? Why do I forget so much? What's up with my brain, I can't fuckingstanditnothingsworkingIcan'tcontrolshit!

I'd killed the rest of the bottle, and another bottle, and considered things from a variety of different perspectives and seriously needed something else to think about, and so he came as called, I myself had picked up the phone.

"There you are."

"Are you talking to me?"

"What do you think?"

"What are you doing out here?"

"Visiting you."

"I didn't invite you."

"Oh, excuse me, then which other Justine was it who called?"

I didn't want to talk, no problem, he didn't want to talk either, we both wanted and needed something else.

"I've brought you something," he said.

"I don't want it here."

"Do you know what it is?"

"Strong beer. Isn't that what you drink?"

"You're way off base."

"That, I don't want. At least not out here. Come with me into the house."

"Do you mean it? Take a look. Looks tasty, don't you think? Should I take you here in the grass?"

"No."

"Just look how big it is."

"I know."

"And so? Don't you miss it?"

"Go home to your wife or come inside."

"Shut up."

"Like hell."

"So touch me."

"Forget it."

"Can't we?"

"Never."

"No?"

" "

Luckily, I had a bottle of gin I could open. Torben tucked away his limp dick, zipped his fly and drained the last drops, together we looked out over the green tree crowns becoming black against orangechangedtoturquoise, and what became of him? We grilled sausages, and then what? We went into the house with the armoire that was no longer thumping. I headed into the city. But before that? I went to Kluden, played it cool until I was so drunk I could no longer manage the cue or the balls.

Grandpa died in the garden house one winter day. He sat in his recliner with a blanket over him and fell asleep, just like my grandmother, and in a strange way, if I'm finally able to see the positive in it, who wouldn't want to go like that? Not by murder, not by suicide, not incrementally by destructive behavior, but undramatically, a death come when least expected, just . . . and that's how Grandpa died.

He'd put the first charcoal strokes on a new painting, and then he'd sat down to let the motif form before his eyes, I thought. Perhaps he'd considered how exactly to come at the painting, had laid back his head, perhaps he'd snoozed, his heart, at any rate, had stopped beating, bum bum b u blmm . . .

The house was cold, and that was good, because he'd sat there for around three to five days. Grandpa's neighbors wondered why they hadn't seen him. Keld, as the guy was called, had gone into the garden and looked through the window. He could see the back of Grandpa's chair and his legs sticking out.

We waited for the ambulance to come and retrieve him, but they'd already confirmed he was dead, he was completely white, after all, and dead. The two uniformed men lifted Grandpa out of the chair, leaving behind the blanket and a brown stain.

"He's my Grandpa," I said. "I'm his only grandchild."

Slowly we drove to the hospital.

"We have other family, but we hardly ever see them. We only see each other. Actually, it's almost like we're all that's left."

The ambulance man said something comforting and swung into the hospital drive.

"I don't know why he's dead. It's fucked up. Now I'm all that's left."

The house was quiet but not empty, he was everywhere inside. Everything had gone through his hands. The marked canvas . . . maybe he was just down at the firepit drinking a beer with the others? I crawled into his bed at night, a pretty dismal place for someone who's lost their entire family. How did he not want to be buried? The white bread in the drawer hadn't even begun to mold. Could that stain be removed? No. Just no.

And you can probably tell, Vita, that you were a Free Me From This Evil, not because I couldn't learn to be alone, and I wasn't completely alone at that, but belonging somewhere is always nice, and he was gone, after all, the one I'd ALWAYS had, and so it was nice when you came, it was nice being together with you. Only half a year or so had passed, and there you stood, radiant in the yard, and we staked our sense of belonging in each other.

Now that you're gone I seek you in all possible directions, and you should know that it's hard, now that I've also got your short-haired woman in sight, the cow. I seek, at least I try, I grope along a chain of Before Now and After. I lift my feet and head that direction. That direction and not that direction. Now I draw away, now I pull closer. With every step I take I accomplish something, I move a direction, I turn away from something toward something, I leave a trace.

Now. No. Not now. Soon I'll be passing a spot, just up there along the path. I know it, because I've set foot there before. Should

I go around, should I go through? I'll cross my own tracks. Now.
Now come the thoughts. They're unavoidable. They're quickening.
They're caught in the trace. Ahhrr.

You smiled indulgently. We sat together talking, you and me and Ane. As usual, Ane was complaining about Torben, and you smiled indulgently. Things with Torben weren't so bad, you thought, and you told Ane she knew what was best for her. You gave Ane a nice dose of security, she was so happy, yes, she was relieved, you're smart, she thought, so what's there to worry about? Before I knew it, Ane, now optimistic, asked how it was going with us, and about our future together?

"The future," you said. "The future . . . well, when it comes to our future, we'll just have to see."

Your tone, your words, it was all made of rubber, pliable. It sounded like we'd agreed that we'd just see about the future. Ane added, sweet as she is, bordering on naïveté, that of course one never knows what the future holds.

What did you mean by all those ifs and buts? Didn't you know how awkward it sounded?

I clasped your body as it collapsed onto the bed, the light was red become black, I straddled you, caught your head below the chin above the pulse, twisted your sweater out of shape as you chimed in with arms and legs, and you, like the dog you are, breathed: "Yes, yes."

The material gave, and you devoured my shoulders with nails then teeth.

Who knows Ane? And who knows Torben? What I do know, for example, and Ane does not, is that Torben is fooling around with some girl from the academy. He was together with her back when Ane was at home with a cold, and that was before she even had the child. One night at Andys Bar I saw him in the far back next to the juke box pressed together with the girl in a deep French kiss. Later I saw him in the men's bathroom, where he stood with his back bent over the girl whose crotch he was in the process of groping. I saw his butt crack, I could've touched him, I could've shoved him. He would've landed on top of the girl.

I couldn't make myself tell her, so I just asked: "Does Torben go into the city often?"

"He should have the right to go wherever he wants to go," she said. "Just because I'm pregnant doesn't mean he doesn't want some distraction. And you know how important it is to go to openings and all that stuff."

"So he's just working?"

"What else would it be?" she asked. "Isn't that also what you're doing when you go to openings you don't want to be at? You do it anyway. Don't you? Why should it be any different with him?"

"You're the one who knows him, so what do I know?"

"And anyway, all that'll be over soon. After I've had the baby. Then we can't just go wherever we want all the time. So when did you see him at Andys?"

"I didn't say that."

"He wasn't together with her, I mean, together together. He just slept at her house. He was too drunk to drive home. Stay out of it, Justine. It's under control, I assure you. We talked about it."

She disappeared into the bathroom and came back with red eyes.

"I don't want to talk about it anymore. It's our business. It's our relationship. It's not always as easy as you think. Just because you go around cheating on Vita, that doesn't mean that other people are like that, too."

"I didn't say that."

"What did you say then?"

"I don't know."

"Why don't you and Vita just move in together already? Is it because you're too scared to find out what it's like to be a serious couple? Anyway, it'd certainly do your relationship some good. Then you'd learn what it's like to accept others as they are."

I never did tell her about the whole Torben thing, and I also haven't managed to do it since. It's a form of dishonesty. It's a suppression in any case.

The house is dead, all that's left is black. Was there ever a house even, and if there was, was it mine? Who's to say that the last few years haven't simply been the extremely concentrated content of a dream? I think I can feel myself twitching, could it just be REM sleep? Are there witnesses to the catastrophe in my life's collapsing?

An investigation is underway, and there's evidence. I'm at the police station, and they know something they're about to divulge. Now is the time to do it, I'm as primed as I'll ever be.

The linseed oil rags weren't at fault, they say, nor the wiring, which I ought to have changed. Nor was it Vita. The fire started outside the house on the cement tiles in front of the door. I'm the one responsible, they said, there's proof.

No. It was my grill, not the grill itself, of course, but . . . now I see it:

The coals were an obvious weapon, and I hurled the grill and crap on it at Torben, the pig, who hightailed it out of the yard, shooting away like a rocket in a swarm of sparks. And the sparks that burned my skin disappeared beneath the tarpaulin of the, oh yes, the enormous woodpile that'd been stacked for the winter. I headed to Kluden with a throbbing ass and burned hands, I sat at the bar until I'd forgotten the whole thing and could safely go home again.

"And unfortunately, that makes a difference to the insurance," says the policeman, but it isn't his happiness that lies crushed before him.

"After all, it's a matter of negligence. It could've been avoided. The clean-up and rebuilding will have to come out of pocket for you, that is, if you're thinking of rebuilding again."

It's painful overall to realize that fact, not because I think that Grandpa's house can simply be rebuilt, or that there's someone

waiting to do it for me. But to be the only one left with the site of the fire . . . that feels very definitive.

Thirteen

When I open the door to my room, the walls are red. The bed, which I left in a state of disorder, has been made. A shimmering coverlet hides the bed linens, it spreads out over the bed, and someone has lit the candle in front of the mirror, the light glows out of the red. Hanging over the chair back are the clothes from the secondhand shop folded into sets smelling of fabric softener. Right away I take my old clothes off and put on a pair of garters and a lace bra and lie down on the bed. The woman behind the camera says that I should draw in my legs a bit more, so that I don't appear so vulgar, "your pubic hair shouldn't be visible," she says. I turn over on my stomach and stick my rump in the air, so that she has a frontal view. I imagine my butt as a gently clefted mountain rising above my naked back, "could you take off the bra and wrap a towel around you instead," the woman asks, "so we can do a kind of bath scene," "like this?" I give her half an eye over my bare shoulder. She likes what she sees and snaps and snaps, I twist around, my body is a corkscrew.

We take a break to drink some wine, "Done deal, perfect!" the woman says. I run over and open the closet, it's completely empty, and grab the huge underpants that I also got secondhand, white with a slight discoloration on the seat, but that hardly matters, they're underpants, after all, no, I'd rather be naked.

I take a healthy slurp of the adrenaline that courses through my veins and slops onto the fabric, then I sit in the closet, "let's do some pictures in here," as I sink onto my back with my legs against

the wall and piss in a stream, allowing it to drip onto my stomach and puddle around my back.

The woman giggles, setting down her wine and moving the camera, "it'll be insanely freaky," she says, snapping and sniggering, "hey wait," I say, "I'm not even alive, I'm dead, I'm lying in the closet out of sight, can't you see that?"

The woman adjusts the lens and zooms in, she flips on the reading lamp and directs it at the closet, "yeah, yeah, that's obvious, sit still, I'm trying to take pictures, you're rotten through and through," she says and wets her pants from laughing. I tumble out and rip the camera from her hands, "let me see," I shriek, "I want to see," we tumble around on the floor with laughter, "no, be serious," I shout and cover her mouth with my hand, "we're not finished, now we have to go down to the foyer."

In the foyer she's another woman. Attractive. Primed. Sharp. We find a white wall to use as a background and photograph a pair of neutral attitudes. She adjusts my T-shirt, "it should either be tucked out or tucked into your pants," she says.

"Out," I say.

I work my body and show that I'm surprised. I'm marveling. I'm mystified. Doubtful. Shocked. All the things one can be all at once.

Justine's eye itches. There's a film over the image is turned milky. She doesn't want that. Where did it come from? From her head out through her eyes leaking water. No. It's not just the eye that's bad, the whole thing is sick. She replaces the patch. She needs a drink.

Justine sweeps through city streets that all lead to the art scene. That's how it's always been, and why is she at the National Museum? That's the exact opposite direction, and the air here is too thin and dry.

Justine tumbles the whole way up the steps of the spiral staircase leading to the showcases, she can see right through the big glass cabinets, all that she's put behind her stands before her. Her pupils dance across bird skins, bird feet, anoraks, pants, Kamiks, and white splotches of salt on a belt adorned with teeth from an animal or a child? If she wants, she can touch something, simply touch, she must be careful, you must wear gloves when you handle olden times, a thousand years ago, grope back in time. Her pupils touch, fondle and touch.

Now the eye is getting worse. Not only does it itch, it hardly even works. Blue violet becomes black. Is Justine about to lose her vision, too? In any case, she's having trouble breathing, and here come two men to seize her arms. She makes a sound, a high-pitched toot. Is she an elephant? They tell her to stand up, but she's already standing on four good legs, you idiots, who the fuck are you anyway? Let go of me, goddamnit, everything is fine, fine, now she stumbles

forward, rises, puts one leg before the other down the stairs where Inngili hangs over of the railing and waves, "come again soon, my girl, come again soon, I know where the animals migrate to!"

A long elastic band draws Justine to Amager Strandpark, backward she bikes with a couple of wine bottles, her legs pump up and down, automatically heading toward Øresund, completely out into the water. At the beach, she takes pictures of the foreign landscape, sky and sea become interchangeable. Pictures. Now she's a beached corpse in the shallows with sand on her skin near her mouth and in her hair. She's been flesh in the water for a while, utterly dissolved, and wine's bordeaux becomes blue in the waves as the drowned one transforms and becomes a drunk man who's fallen asleep up a tree, wakes up wet in the night to true dark. He can't figure out who he is, is he a woman, is he a man, or perhaps a child? He's a child who pushes the patch, which has slipped down his cheek, up onto his forehead and inhales deeply. He isn't just a child, he's also a woman. Justine.

I really should, I hate that word, I really should have gone to the openings out in Valby, I should've. Now I ought to pull myself together and swear to do it tomorrow. I swear it. No more corpses lying around at low tide.

The street kitchen made the newspaper today. If I cover my bad eye with a hand, I can read all about it. That's certainly not good, but it's still better, and obviously it doesn't help that I'm sitting in this closet, so I let some light in and force my attention on the newspaper. It's mostly photos. The journalist is fascinated by the fact that garbage can be turned into food and has taken several close-ups of munching mouths.

I flip to the last page, and now it's dull again. When I uncover my eye, violet fills the space. Why can't anyone discover what's growing wild in my head? The nurse didn't even call a doctor, but what does she know about brains or whatever? Now I'm forced to ask Vita, who's not a doctor, but who nonetheless has a certain understanding of all things. I'll say to her: "It's not great, what's happening, but maybe we can still be there for each other." And I'll say: "If we want to. And I want to."

We can still be a lot of things for each other, we still can, only not today.

The days drag me along, and the office manager at The Factory stopped by and knocked because he wanted to know how long I'd be staying. He looked down at me with watery eyes. If I'm going to stay more than the month, he said, we need to draw up a sublease, even though he knows Ane is on maternity leave. Even then.

Maybe he and Ane crossed paths when he left, I don't know, at any rate she's standing in the door. Torben has taken the day off, he's watching the boy, and she wants to know how my eye is doing.

"I don't know," I say.

"You dropped the patch? I thought you'd put out your eye or something."

That's right, I'm sans a patch, I'm trying to get used to the fact that things are now rotten.

"I've just come to check on a few things," Ane says, glancing toward her paintings. I ask:

"Should I leave in the meantime?"

"If that's okay?"

I make four laps of The Factory, but I'm hanging by a shred, I'm thirsty, I'm splintered, get your act together, I say, you're more than just your present state, you're also a far stretch into the future.

I take myself firmly in hand and walk in and look at Ane's paintings spread out over the floor.

"My breasts are ready to explode," she says.

She still hasn't left.

"It took longer than I thought."

"What are you going to do with them?" I snigger.

I mean the paintings, of course. What's she going to do with them? They're lying there, she's signed them all.

She glances my way with her mighty big breasts, which are about to explode.

"I'm going to take them home. But now it looks like rain," she says.

She rummages under the table, finds some paper, finds some old canvases, some rods, some poster rails, and finally some rolls of plastic.

"Sorry, Justine. I've got to run," she says.

She picks a corner of the role with a nail.

"I don't think I've even told you," she says, "what ended up happening with Torben's gallery and me. Did I tell you that? Did I? You know that Torben has given some serious thought to leaving his gallery, right? Anyway, he's not going to do it immediately. He's decided that the most reasonable thing is to stay and maybe try to make it abroad sometime. If he decides he can't take it any longer."

Ane smiles with bristling teeth.

"He thinks my paintings are tight," she says.

"Tight," I repeat, the word tensing my mouth.

Ane smiles and smiles. Is that really her only grimace? She's tidy, it suits her and her situation. There's an aura of good fortune and happiness about her, it's going so well.

"We've agreed to do something together for that exhibition, the one he couldn't think of anything for. My paintings will work in some way or other. Anyway, I'll have them framed, then we'll see what we can come up with."

"So he's going to use your works in his exhibition," I say, smearing it on.

Ane's eyes narrow to slits.

"That's not how it is. I don't know what you're thinking, but he's got something in mind."

She grabs the roll and starts, eyeballing it as she goes, those beautiful eyes. She finds herself a spatula, rip, rip, tears off the piece she wants to use, it's long, at least three meters, she wraps it around the paintings, slowly, until all the pictures are encased in a covering.

Then I ask a harmless question, one that's got no bite: "So who's doing the framing?"

Soon she'll be out the door, heading home, back to all she has.

"Hans's Workshop," she says. "Torben got a job there a couple of days a week. He'll do my frames in the evening."

Should we get together someday, just you and me? I can't ask that, or rather, I can't bring myself to ask it.

She busies herself with this, that and the other, the scent of breast milk is a cloud around her. When she bends over, her chest hangs like two udders.

"It's really annoying to have to be back so quick," she says, turning around, "I really hope things level out soon."

"There aren't anymore," I say, she's standing oddly halfway out the door, as if she's forgotten something.

"See you soon," she says.

"Maybe one more time," I say.

"I hope I have a little more time then."

"Doesn't matter."

"Good luck with the exhibition."

"We'll see each other before that." She gives me a strange look. "It's several months away, you know."

And now she's gone.

Could've been the beers. Could've been because she popped into my mind. Could've been because I was thinking about Ane and felt that Torben was an idiot. On the other hand, that's always been my opinion, and recent events have done nothing to improve the situation. And the exhibition, which I'm supposed to be having soon, I thought about that, too. Could it be because that popped into my mind? It's certainly possible.

A minor detail. Even Torben's a minor detail. Something else looms larger. And that I didn't dwell on at all. It wasn't a thought, but an urge, no, something stronger, an impetus, that's what it was. That's what the desire to sit in the armoire with my mother felt like.

She lived in that armoire. A Kirkeby sculpture with a large poppy on the door, itself made of stone, located in a small housing cluster. She's inside that house. It's around ten, no, twenty steps to the door. There's a crunch beneath my fire shoes. One step, two more, a braking vehicle, the ambulance, from the corner of my good eye. Two men with a stretcher dash, the door opens. At my seventh step I can no longer lift my legs, my stomach burns, my arms burn, so heavy. I need to shit. Right now. But I can't shit now where my mother . . . no, Vita . . . my throat, burning. She gasps on the floor in a puddle of nothing I can do. Not even lift my arms. My legs twitch unevenly in piss and shit, seriously, I need to crap, but I can't move, she shouts from inside the armoire everywhere.

Should I do it in my pants, what's the most important thing here?

I topple to the side in the grass, a mighty big intestine in a teensy tiny worm that worms its way around the house and unseals the hole, explodes onto the grass, lies in the grass, stinks in the grass, until someone happens by and says: You're me, so get the hell up! I have arms and legs, so I push myself up, peer through the window at a TV, and she's sitting in front of that TV in an armchair, "Mama," I shout and race to the door. They're bearing the body out, it's there beneath the sheet turning chalk whitey white with an oxygen mask is dissolving to dust, smothering, and smoke is pouring now from the door, from the gaping windows, too. I look again: She's sitting in the armchair, studying the canvas, she turns her head fuming,

glances toward the window, lifts a hand, rosy-colored cheeks and that particular hairdo from back then, so beautiful she's a delta of melted skin become a single brown smudge on the way out of this world again.

Out here is utterly deserted, the house has never seemed colder and harder, strutting its single level won't ever collapse, now there's no more key, no way inside.

Yet in that part of the yard that's invisible from the road since it's behind the house, they're sitting together, snuggling in the torch-light that flickers and flickers, and the shadows dance on their faces and in their eyes, which don't see me, they're consumed by each other, they kiss, they lean close, their garden chairs give beneath their weight as they lean over to rub noses, the short-haired woman and Vita.

The pitchfork stands leisurely in the flowerbed, only the shaft is visible when the light flickers that direction, but the teeth are hidden by the soil.

The women suddenly glance up, peer into the dark, appear transfigured and embrace each other, tilt to the side, and the short-haired one grimaces, puts out her hand and lands softly in the grass, flump, with Vita on top of her on her full breasts, they spread out in the grass like an island of flesh in green.

They peer into each other, they don't see me standing over them with the pitchfork in one hand.

Now I wrap both hands around the shaft and heft the tool, which actually weighs a bit, above their body, up above us the sky is black, and I want to lift the pitchfork even higher, as high as it can go and higher still, before I allow it whizz through the air and pierce their heart.

The pitchfork's teeth pierce the clothes and the skin and bore into the double body which doesn't flinch at all; no reaction; sedate as a jellyfish is slow.

Now it's like Grandpa, like the house, like . . .

I excavate the ground with the pitchfork that's not meant for this, its teeth simply part the earth between them, an endless task, I place it beside the body and walk over to Launis's tool shed, there has to be a shovel or something else fit for digging, no one will discover anything, it's smack dab in the middle of the night, fortunately.

I pass my firesite, something has happened, the area has been blocked off by red and white plastic tape, suspicious things are going on, not that I know what they might be, my vision isn't the best, but it has to be the police, and what's that about?

There's also a tent that wasn't there the last time, now I've got two things to think about, it's just too much to cope with for a person with her hands full of too much of everything, I simply can't take it anymore.

All is quiet in Vita's yard, the grass glints green in the light of the flickering torch, but nowhere is there a body, while the pitchfork, which has landed among the potatoes, lies there uselessly, the shadows are also gone, and all the chairs, it's just that one torch and Launis's shovel, which turns out to be a spade.

In reality, the body is nowhere, not even in the house, which is locked like a bunker.

I putter in the dirt, the spade's handle is made of metal that easily enters the bedroom window after I wrap it in my shirt, no one needs to come here and see this, there's nothing to see anyway, the whole scandal has been scrubbed.

Fourteen

Clothes. A stringy cassette salad. Empty tapes. DVDs. Me. On the floor.

"Am I okay? I don't think so."

A large and mournful and rather gratifying cassette salad is heaped on the floor in streams of images and sound. No point in trying to fix anything.

"Are you okay?"

It's Bo. I didn't close the door and he simply walked in.

"You must be really down," he says.

"Can you tell?" I ask. "Can you tell how it's all connected?"

I can't help it, but start crying all over again, mostly because of the ruined tapes. I actually could've used some of those recordings for my exhibit. That's what I should've done. It would've been easier.

"But why in the world . . . why did you destroy them?"

"I don't know."

"You're not too bright."

"No."

"Were you drunk?"

"Yes."

"Well, that explains something."

"No."

Bo has suggested that I borrow his computer, he's so great, so I can look at my photographs. His workshop is the same size as Ane's, but packed with things from floor to ceiling. In the midst of it all are two desks set across from each other and piled with paper. Bo sits down at one desk and puts his legs up, he's about to tell me something, but then there's a knock on the door, and in comes Åsa with another guy.

"How's everything going?" the guy asks. "Did you get ahold of the cans?"

He's tall and skinny with oversized pants, everything about him is too large, except for his head, which perches atop his skinny neck and seems way too small, though his nose, on the other hand, is enormous.

"They're over there."

Bo indicates some boxes.

"Five boxes of peeled tomatoes. It's just the paper that's rotten."

"Super."

The skinny guy offers a bony hand in greeting, since hey, I'm here, too.

"My name's Heroine," I say.

His name is Olaf.

"We're running the kitchen again this Saturday," Bo says, "in the courtyard at Amalienborg Palace."

"That's a nice place," I say.

It's like I'm a part of the conversation.

"It's not really the kind of place they like to see bag ladies, eh?" Bo asks.

He turns around and closes his computer program.

"Well," he says, "you can just have at it."

I'm alone in a strange space, but luckily all the workshops are similar. I connect the camera, a moment passes in which I'm excited, and at the same time completely apathetic, the two feelings are on parallel tracks, it's impossible to tell when I'm riding the one and when I'm riding the other.

The photo program opens, thirty something pictures pop up on the screen, I immediately make two groups: self-portraits (staged photography) and self-portraits (snapshots), which means, since it's only me in the pictures, that: 1. It's me pretending to be something else, and: 2. It's me being me.

I try to divide the pictures between them, but they insist on leaving their assigned group and scattering. I decide to create a few sub-groups: 3. Self-portraits (unsuccessfully staged pictures turned snapshots), and: 4. Anti-self portraits (unsuccessfully staged pictures failed to become snapshots, loss of control), and: 5. Non-category.

I shift the pictures around again, it's like they're multiplying, now they're caught in so many layers that I can't keep track of them, wait, wasn't there also an opening I was supposed to go to. Didn't I promise myself . . . I grab a couple of beers and head out.

It's a small place, a small basement gallery, nothing uncomfortable, just some people from the school and such, all standing out on the street and smoking, and there's Jens Erik, he's the one exhibiting down there in the bright space on a balmy evening.

"Hey, Justine, come have a beer, they're in the window."

Warm beer and Jens Erik's works are a good combination. He's taken photos of the graffiti found around Vesterbro's streets and has made patterns of them. It's kaleidoscopic, these mystical mandalas that draw the eye around the designs and "what beautiful movements," says Rikke, she's here, too. "You don't even notice that the words 'fuck' and 'shit' are actually in the patterns."

I think Jens Erik's pictures are fantastic, and I can tolerate Rikke only at a distance. Two hip-hopsters are at the turntable, and now Jens Erik goes up and scratches until his beer bursts, the show gathers and becomes black vinyl, people rotate by, the crowd is at a comfortable distance, and here in the corner is my overlook.

My plan was to hide from anyone who wanted to talk to me. I knew that they'd ask how it was going, and it's going to hell, no one can fail to overlook that, not even myself.

But see: Here comes Torben, goddamnit. He doesn't see me, I'm invisible to him. Torben throws an arm around Jens Erik, who's finished with the records, and says, as far as I can make out through the din, that it's aces what he's done, total aces. He jerks his head, jerks it back, he laughs and throws back his head. Ha. Ha. I stuff a couple of beers into my pocket, because being unable to cope with

yourself is one thing, being unable to cope with this underground gallery for one second longer is another.

"You've got some nerve," says Torben, who's managed to find me nonetheless, who slaps my ass with his eyes.

"You're an idiot," I say.

I take some photographs in The Factory's workshop. The Salvation Army, the nursing gown, the rainwear, some glasses, the beard, all the nice costumes zip around the studio and want to enter the iris, but I keep them out because I've decided they can't play. Now they're heaped on the chair. I've decided, and it's me who decides, that I'll only photograph my body, and it'll be as simple as possible. I'm wearing white panties and a bra, and I oscillate back and forth between the camera and stage and assume every possible position.

Things between me and the camera and the stage are much better now, in any case much better than they were at first. I've stopped screaming and kicking things, but instead hurry to the camera, hit the timer, and then hurry back to the stage. My body is more tranquil now despite these quick releases. I can work with it, unfold it from within to sorrow, to sorrow and general unhappiness, and to jealousy. The picture I snapped just then was amusing. You can't call it bliss, but I did laugh from somewhere on the inside. That was wonderful.

And now I've just been to Bo's to see the pictures on the computer again. They actually do look better.

Why the hell didn't Vita say she had someone else? I know she'd say it was none of my business, but it certainly was, it most definitely was my business. Every sticky detail touches on me, the drooping teats, the hedgehog hair, she wasn't even attractive. Neither are you, she'd say, Vita. The cow. Hell yeah I am, in any case I'm better looking than that old hedgehog. Shit, I can see that with my own good eye. She sat on my couch. She sat in my garden and drank from my glass. She sat on you. You were someone else, but you looked like yourself. You were hers.

What were you planning to do, stroll past my house hand-in-hand with her? Good thing I'm not there anymore, huh?

Ane stands in the studio. She entered without knocking, just to find out if I'm finished with the camera, because she'd like it back so she can take some pictures of her work. She's also different. There's a new energy about her. Everything is in a flutter.

"How's it going?" she asks.

"Vita's with someone else."

She looks at me. I'm a mountain to be hurdled.

"I know," she says.

"You do?"

"She told me just after Christmas."

"But back then we were still together?"

She looks like a tough hen.

"What, did you talk about it?" I ask.

"Of course we did. She doesn't have many other people to talk to. Chill out, Justine."

What did she say to Vita? How did she say it? In what words? Where did she put the emphasis? And why are both of my eyes suddenly clear-sighted?

Using eyeliner I draw a dotted pattern down my chin. Using lipstick I make two lines on each cheek. On my forehead I affix a red mark from an old exhibition. I look, and I look good. That's some sweet war paint.

The bus is stifling, and no one does anything about it. I have to squeeze between the people who stand pressed together in the center aisle, next to a man who mutters that it's only the driver who can open the window. Now I hardly have any air, and what's he standing there mumbling for, the big idiot.

Luckily, we're nearly inside the city. We drive past Christiansborg. At Kongens Nytorv we idle between cars and buses in a long line waiting to reach the actual bus stop.

People get off. They wonder what's wrong, no one knows anything. There's probably a demonstration up ahead.

Now three police cars drive directly across the square, weaving in and out of the planters and trees. The cars try to pull onto the sidewalk so the police can make progress. Now they somewhat make it through the congestion.

I sprint with the others up Bredgade. It's a contingent of the country's free-roaming tramps speeding along with old strollers hung with raccoon tails, and some young people. We race toward the shouts and commotion ahead.

Now there's the smell of fire. From the church I can see down to the courtyard through a cloud of smoke. People swarm up the

street to escape. It stabs at your nose and eyes, and I take off my T-shirt and hold it before my face.

Suddenly, there are policemen right before me pushing their way forward with shields, flying bottles fill in the air. A rock whizzes over the police and lands next to me. And there's Åsa in some policeman's arms. He's holding her away from him, so that her arms and legs operate like drumsticks in the air. She shouts soundlessly. I run toward the policemen, I'm a battering ram, I bash straight into a club.

Fifteen

Overhead is a concrete ceiling. Outside on the street a couple of people dash past. I have a headache and a lump on my temple.

"Some people dragged you in here. They asked if they could leave you here."

I'm lying on the floor of Galleri Kold in Bredgade. That's why it's so white. The man talking is the director.

"I'll drive you to the emergency room, but I think we should wait until the street has calmed down a bit," he says. "Can you wait that long or is it really serious? How are you doing?"

I'm lying on a blanket. What he's saying makes a lot of sense, I think.

"Is it serious? Should I call an ambulance?"

He crouches down.

"Sorry for asking. But what is that you've got on your face?"

"Nothing," I say.

"Oh, okay . . ."

His name is George Kold. George Kold finds a pillow I can use while he putters. I try to keep my eyes open, but they close.

I'm lying there gently rocking. It's a little cooler today. And firm. Now I touch ground. And there. There on the beach is Torben. He looks like himself. Just so. He steps close. Now I can see that his nose resembles a moonscape. He bends over me. I can see right into his brain. He laughs in my face with breath like old fish. I want to roll away from beneath him, but he falls on top of me. Heavy. Not just heavy, but reeking and heavy, I'm being pulverized by bad air.

Somehow I've freed my leg and can bend it, I drive my knee straight into your crotch, you howl, fall back. I stand up and jump over you, I kick your body, that makes you turn over so I can really see you lying there beneath me. You grab your bulge with both hands, don't go unzipping this time, you, it won't work.

You snort, just as loudly as you snorted that evening. Oh certainly, of course I wanted to, no doubt about it, that was the whole idea. She'd hear it and taste it, how she'd regret it when your dick squelched in and out the evening it burned, because "now I remember, you sorry shit, I remember it all. I said no, when it came right down to it, I said no, I didn't want to after all. Just because I was drunk didn't mean that I was horny. I couldn't do that to her, not to her, not to Ane. It took you by surprise. And me too. Otherwise, I'm always up for it, the fact is, I can't stop. But suddenly I couldn't anymore. And I told you that. But you acted like you didn't understand. You struck me. You struck me hard. You hit me so she heard it. I said NO. You slammed me to the ground, started pounding, pounded it right into the hole. Oh, the pain was horrendous. I'll

pummel you. I'm pummeling you. Now you're lying there, Torben. There. I can put my foot on your chest. You pathetic pig. I spit in your sniveling face. You perverted, pathetic pig. Do you feel the pressure? Goddamn it, you're going to know how much I hate you. You're to blame for so many things. You're to blame for the house. And for Vita. Did you know that? She was in the armoire. Now the armoire is no more, and where does that leave Vita, do you think? Your fault. You did it. If you hadn't come, none of it would've happened. You brought me to it. I'll hit you, burn you, I'll never forgive, I'll never forgive myself. Never, never, never, I've already started to pay. Dearly. And now, goddamn me, you'll pay too. Are you whimpering, you salivating asshole? I'll tell you what you've done, in case you don't remember: You raped me in the ass. You burned me down. You razed it all, oh no, and Vita, oh no. Take *that* for *that*. I'm grinding my heal in your mouth, Torben, take that, grinding your teeth into your maw."

When Ane went into labor, I borrowed Vita's car and sped to her place. By the time I made it to her apartment, she way lying in the entryway and wailing with blood seeping between her legs and down her thighs. I called an ambulance, which arrived ten minutes later. The medics said it was a good thing I'd called and carried Ane downstairs. It took two men. On the ground they put Ane on the stretcher on all fours, she panted hysterically.

"I need to shit, I need to shit," she said.

"No, you don't, you're about to give birth."

"Yes, I do, I need to shit."

"Don't push right now. You hear me? No matter what, don't push, you hear?" the ambulance driver shouted.

He looked like someone who knew what he was talking about.

We drove with sirens on to the hospital, Ane was wheeled into the maternity ward with me loping along behind her while I tried to figure out where Torben might be. During the next hour, the midwives and the doctors determined that the boy had the umbilical cord wrapped around his throat, and that he was breached, and so Ane was given a C-section.

She lay snuggled in the recovery room afterward. The baby, a big, beautiful boy, was doing well, the nurse said. She dressed him and handed him to me, so that I could hold him until Ane woke up. An oversized romper and a cap that kept sliding over his face. As soon as Ane came to, she took him. He just slept. Ane lay there with eyes dark and said nothing.

"Do you know where I can find him?" I asked.

To her there was only the baby.

"I think you should try to get some sleep. I'm sure he's on his way," I said.

At six in the morning I drove all around Nørrebro and looked in at Café Louise. Torben was sitting at the bar, well, there's sitting and there's sitting, he was bent over an ash tray together with a yellow-haired girl, and it smelled of piss.

"**I** hope you're better today," George Kold says.

He sets a cup of coffee in front of me.

"You cried out during the night."

"I cried out?"

"Yes. Or rather howled. I got up to see what was the matter. You just lay there on the floor howling."

While I was lying here, they've been cleaning up outside, they're still driving the street sweeper around, I can hear the brushes. Now I sit up. A throbbing. George has gone to the back to make more coffee. Both my eyes can see. They focus on him. They're sharp. The lump is nothing more than a tender swelling on my temple, and I shake my head, no sensation, just a rotating faintness, my brain is full of memory loss.

Down on Bredgade they're in the process of removing a torched Mercedes, otherwise all is quiet, which is also the case when we head out of the city and onto the highway, there are hardly any cars.

"Here. Take my glasses," George says.

How can a simple pair of sunglasses feel so entirely wonderful?

The emergency room nurse says she's seen me before, but I don't believe it, how is that possible?

"It's good you have your vision back," she says. "That's what I told you would happen."

Oh, yeah. That is what she said. She's the one who was so unfazed by my stupid eye, nothing to worry about, she said, just like now.

"So what does it take for you to give someone a CT?" I ask.

She gives me a long look and says it's not necessary, she's just examined me, after all, no reason to think anything's wrong, I just suffered a good blow to the noggin.

"But what does it take for you to scan someone like that?" I ask.

I'm not crazy, although she might think that. I'm completely calm.

"What does it take?"

Now I'm that mountain again. I see it in her eyes.

"If a person has vision problems and has hit his head and also has some screwy family members, would you give them a CT scan then?" I ask.

No. They wouldn't. There's nothing wrong with me. Fortunately.

Now it's evening and Bo has only just returned to The Factory. With a black eye and his arm in a sling, he was slumped on a pile of rockwool, completely done in, when I found him.

"Everything was obviously going smoothly with our kitchen," he says. "In any case, it was going so well that everybody figured they might as well demonstrate against anything and everything. Doesn't matter that we'd already agreed how we were going to act. When other people have other ideas . . . and just do things that are so piss-in-your face provocative."

He was stuck in the middle of the demonstration and threw a pot at a cop. In return the cop twisted Bo's arm behind his back so vehemently that it was dislocated.

His arm is extremely painful and Bo extremely tired. His eyes keep closing. I close my eyes, too.

"Do you need anything?" I ask.

"Do you need anything?" he asks.

"And what about Åsa? She's got it even worse. She's in custody for biting a cop's ear," he says.

"Did she bite it off?"

"No, I don't think so. But I have no way of contacting her," he says.

"So how do you know?"

"Some of the others saw it. We're going to meet up later and try to start a collection. We need to scrape together some money for her fine."

"I'd be happy to contribute something," I say.

Bo isn't listening, he's fallen asleep. He makes hardly any sound, just a slight whistling from his nose.

Sixteen

Grandpa makes that particular Grandpa gesture, waves his hand disparagingly and says "pff," which means we're talking about trifles. Nothing but trifles.

"She's not even worth it," he says. "Pff."

"You might not think so, Grandpa. But I think so. You don't know anything about how I'm doing."

"Hah, I most certainly do," he says. "You're just doing how you're doing."

"That makes a lot of sense."

"Well, if you'd just let me speak my mind, my girl, then . . ."

"No. You always have an answer for everything. But now you also have to try and understand that there are some things you know nothing about. Because maybe they're not about you, Grandpa, but about me. They're about me."

"Good."

"What's good?"

"Good, I say."

"And so you've got nothing to say about it?"

"Well, you don't want to hear it."

"Out with it already."

Grandpa makes a new gesture, not exactly the same as before, but just as Grandpa-esque. He raises his eyebrows to indicate that what he's about to say is important.

"Well," he says. "What I wanted to say was just this. Ahem. What I wanted to say was, I don't think she treated you well. I

thought she was a little rough with you. And there I go, about to call you 'my girl' again, but I won't do it because you don't like it. But I simply think she could have treated you better. Or, in any case, she could've treated your things better."

"My things."

"Yes, well. How do I explain it? Your artworks, Justine, your works, damn it. I know very well that I wasn't always polite about it when you tried to explain something to me. But that's another thing. I'm your father, you know."

"You're not my father."

"No, no. That's not what I meant either. I just mean that we're family. We know each other, not . . . We don't need to tiptoe around each other, eh . . . But she was your girlfriend. Or lover. Or what do you call it when two women are together? Anyway, it doesn't matter. But it's another thing when you're a couple. I think she only liked what she'd made herself."

"You didn't like what I made either."

"That's true. But I'm a bit old fashioned, Justine. You know that. Is that against the rules or something? Of course not. But that also doesn't matter now. I certainly liked you, at any rate. That's for sure."

"I know that."

"What I'm wondering is, if she really liked you. She was certainly displeased with you, wasn't she? But you also weren't entirely honest with her. Wasn't there something about you running around with a bunch of men? That's not something a person likes to see when they're in a relationship, huh? You're well aware of that, no? But to hell with all that. Leave it be. There's nothing more to be done about that side of things. But of course that doesn't mean that she shouldn't treat you well when it comes to your art, Justine. The two things should be kept entirely separate. And that's especially true when you're a couple. But what do I know? I'm just an old man."

"It doesn't matter anymore, Grandpa. She's gone."

"Yeah, isn't that the truth. She's not too honest herself though, that one, not since she's found herself another woman. To hell with that, my girl. You need to think about moving on. Don't you have something else you can focus on? Sure, you do. Damn it all, you need to finish your exhibition. Isn't it for the National Museum?"

"National Gallery."

"Yeah, yeah. What do I know. So what will you do? Aren't you doing something with those pictures you've been taking? You shouldn't let the fire bother you too much. It'll work out, you'll see. And now you're also involved in a whole new project. And the house, you'll get it rebuilt. I'll talk to them."

"But I just don't think it's working, everything I'm doing, that is. I don't know if those damn photos will ever turn out."

"Well, girl, let's look at them together. Maybe I can help?"

"No, you can't, Grandpa."

"What's that frown for? There's a good chance I can help after all. What a thing to say."

"Okay, then take a look here. There's no direction. Just a bunch of costumes. It's not honest. It's too desperate. I feel like a pirate who's lost his wooden leg. No. I don't know how I feel."

"Let's see here. What about these? These are very good. The clothes don't intrude too much here. Because you're right, and I'm not trying to be unkind, but that masquerade you've got going in those other pictures is a little ridiculous."

"You mean these?"

"Yes. They're too ridiculous. But these here, these are good. They remind me of those ancient statues. You know, the plaster ones. You're familiar with them. Aren't you? In any case, you're just as expressive as those. Yes, you look like some of those old statues. You should take more of these. Can you do that? Or are you already finished? No, you're not finished. You wouldn't be sitting here otherwise."

"But I can't do it anymore, Grandpa. I just can't. I don't really think it'll work anyway. I don't know."

"So what did you have in mind, sweet girl? Were you thinking of running away? That wouldn't be like you. Where would you run? No. You just need to grow a little hair on your chest. Just like your old Grandpa."

"That's easy for you to say. So why don't you give me some direction, Grandpa. If you're so smart."

"I've already told you. But first see about ending it with her, what was her name again? Get it over with! You shouldn't worry so much about that. It'll all work out. I heard that she'll be disappearing from the allotment society soon. Then she'll leave you in peace."

"What's that supposed to mean? Have you heard something about Vita? But that's impossible. Where did you hear it?"

"Don't worry about that, I'm telling you. It's just something I know. Anyway. But when you've put a little distance between yourself and that woman, I don't know exactly how you'll accomplish it, take a few more of these statue pictures. They're good, I'm telling you. And now be smart and listen to an old man. They're good."

"I have no idea how you know that about Vita. Where do you think she's going to disappear to? Didn't she already leave? Do you also know something about that?"

"I really know nothing. But that's also beside the point. You should take more of those pictures. That's what's important. Not whether some female is running here or there, or whether she's hiding out with some other female with short hair."

I want to ask how he knows the woman is short-haired, but Grandpa is done talking. He gestures with his hand and makes his sound, and then he continues whatever he was doing. I have no idea what it is.

Since Ane has her camera again, and the gods know that I was happy to get rid of it, I've bought my own. Trine Markhøj has loaned me her podium. I also talked to the office guy and got permission to use the hall for two days. There are two walls on wheels there that can be pushed back and forth, I've placed them together so that now they form a corner, a small space, or a theater scene. I've taken a mass of pictures. Many of them are like those I did before, but somehow or other they're still new. The light in the hall is white dust drifts softly onto my body of flesh and bones can move and twist and turn. My face is a mask with eyes and lips that glide up and down, tense, relax.

I look through the pictures, twenty-five have something special, they're simple, one expression at a time, an alphabet. Some of them need retaking. I scribble some keywords on a piece of paper. Soon I'll go into the hall and take the last of them.

B ut on the floor is a card that's been shoved beneath the door, and it's from Bent Launis. He's tried calling, he writes, perhaps he didn't have the correct number, in any case he can't reach me. His mission is important, he believes, it concerns a motorhome someone in the allotment society is selling. He, Bent Launis, that is, thought the society could go on and buy it. What he actually wants is to buy it so he can loan it to me. Later there are undoubtedly others who can also use it, he writes, if they want to remodel or something. He writes in such a friendly way, or rather, it's not friendly, but it feels comfortable. He doesn't know what's going on, there's just this piece of information: I can loan you a motorhome if you want it. And there's also the consideration, the fact that I'm on Bent Launis's mind and also now on a card lying on the floor with a question that can be answered.

The motorhome is down at the park. They couldn't get it into the yard because it's still blocked. You can't break the barrier, Launis says, there are people rummaging about in there, but surely they're nearing the end. The people rooting through the wreckage have also been going around and asking the other residents various things, Launis thinks they're rather nosy, why can't they just be done, how hard can it really be? They have to take into account a person like myself in this type of situation.

The motorhome has a toilet and a small water tank, a bed at one end and a kitchen at the other, and beside the window is a gas burner. The gas container goes in the box below. Henriette Launis has installed curtains. She also wants to put a flower on the windowsill at some time or other.

"We have to see about getting all that fire waste cleared away," Bent Launis says. "It stinks up the whole area."

I'll answer the question.

"Otherwise we'll have to rent a digger and dig it out ourselves. That's certainly something we can do. I'd really like to know when they'll be finishing up there. Do you know what they're looking for?"

Launis pats the motorhome, an old friend.

"Looking for?"

"We'll have you here again, my girl. Something's missing when you're not around."

He looks at me, a nice and manageable hill.

For my part, I'm casting about in the water. Grass blades are beginning to spiral green wreaths around the black behind the barrier. It tickles. The current bears my body around about within. What a beautiful coastline on every side. There. On the shore is the decision ready to be made. It gestures. I'll wait a bit. Here I am. Floating. Above. A cord is being pulled. Now there's a light. The decision is a lighthouse. Imagine living in a lighthouse, with pots, glasses, and cups, with a mattress and a floor lamp, a folding table and two chairs. Here comes Launis's daughter splashing along. She has a drawing in her hand and says: "I'll hang it on the wall." Now I'll just make for the shore, then I'll go and move into the motorhome.

I'm thinking of Ane, mostly because I've just visited her. I said:
"I'm sorry about it. I'm sorry for everything."

"How can you be sorry for everything? There's no reason for that," she said.

"You're unbelievable," I said.

"You say that all the time. What do you mean?"

I said that it meant she was different, different than me, she just does things in another way.

She said:

"I'm not sure I know what you're talking about. But I know that you're still mad at me. There's just not much that can be done about it now."

Actually, it's nice that she hurts me a little.

"I think you need glasses, Ane."

"What?"

"Nothing."

"I've thought about it. It's so strange, Justine. I see a bunch of things out of the corner of my eye, but I'm not certain they're right."

"They're definitely right. I think you can count on that."

I thought about the time she had the baby. He was so tiny and gray turned red, completely nice and unspoiled. I thought of the long cut in her belly, of the interior stitches that would dissolve of themselves, and of the boy that wouldn't nurse. I thought of all the small adjustments that happened when he came into the world, the continuity that broke and took intimacy with it.

"No, no," I said. "There's nothing to do about it. It should've been done ages ago."

When I was about to leave, she told me that she would rent her studio to an artist from Sweden. Now she would stay at home with the boy, and also babysit another boy. Now she would make some money.

M arianne Fillerup makes some final adjustments, wipes a couple of greasy fingerprints off the glasses that the errand boy left. She sighs, not with irritation, but because she's satisfied, her body speaks its satisfaction with a simple attitude. Now she also says it in words: "It really turned out great."

There's a kind of tranquility over the whole exhibit. I've hung up thirty pictures. In a separate room I'm showing two videos that are cast by two projectors in one corner, so that the images almost blend together.

The photographs are each the size of a fully grown body and hang side by side as living sculptures, each with their still meaning, documenting a single narrative's multiple states.

"It doesn't matter that your settlement combusted," Marianne Fillerup laughs, "if this is what replaced it."

The bar is being set up, two cases of white wine and five cases of Heineken. The bottles look handsome beside the glasses, it all looks so handsome there on the tablecloth. Now the first guest arrives, it's still early, but nonetheless. It's just a museum employee, but behind her comes another guest, someone I don't know, now more guests are arriving, there are many, artists and still more artists, many more, I don't know them and yet I know them, I'm about to lose the overview, and now Marianne Fillerup is going to speak, she'll open the exhibition.

"I'm so satisfied with the result," she says.

She emphasizes the SO and looks at me, so satisfied.

"For me it's a great thing to open an exhibition that's so simple and yet so complex. It's a wordless language that's spoken here, the language of the body."

She's really sweet standing there and meaning what she says, she's happy, it's her project, too, there's something luminous about her, she beams at the photographs that beam back at her. Maybe it sounds strange, but right now I'm also glad the settlement combusted, to use Marianne Fillerup's word, or what do you say, Inngili, now: you're still here? Do you think this is well done? You shrug your shoulders, do you think it's amusing? Well, now people are clapping, Marianne Fillerup is finished, and the exhibition is open, and here comes Ane together with Torben and the boy, who's asleep on Torben's arm. Ane walks quietly up, squeezes my arm and looks content, she peers curiously at the pictures.

"I almost don't recognize you. Maybe because you look so normal," she says.

"Normal?"

"Maybe normal isn't the right word, but so still and peaceful. You look still and peaceful even though you obviously aren't still and peaceful. It's your opening, after all . . ."

"Still and peaceful is good enough, thank you very much," I say.

"Congratulations. It's great," Torben says and walks over to the bar to get a beer.

"Will you show me the videos you made?" Ane asks.

I'd love to.

We go into the dark room together and watch the two projections. The images are cast onto the walls in one corner, staggered in time, but living, and also still like photographs. I've posed while the camera ran, multiple consecutive movements, almost a dance, a slow pantomime.

"They speak to each other, the two recordings do," Ane says and nods. "And still they don't have a lot to do with each other, those two women there."

"I'd like to talk to you some more," I say.

"Sure, of course," she says.

"We'll do it soon."

We return to the other guests. Bo has come, too.

"Congratulations, congratulations, Justine. Man, this is tight."

He's in a good mood, his eyes sweep the room, his mouth is large and smiling and moist. Now he's apparently found someone he knows, and here comes Trine Markhøj.

"Wow," she says. "It's sculpture. It's truly sculpture!"

Someone taps me on the shoulder, George Kold, I knew he'd come, that is, I didn't actually know, I thought he would. Or I hoped he would. I stopped by his gallery with an invitation and also to explain why it was so crazy on his street that day. George Kold wasn't especially interested in the demonstration. He was more interested in seeing what I worked with, and he liked the fact that I was exhibiting in X-Room. Galleri Kold hadn't been on Bredgade long, but George Kold has some good artists, and he thought I should invite him to see my studio. I suggested he come to the opening, and now here he is, adjusting his glasses, looking around.

"Yes, yes, exhilarating," he says.

Yes. I don't know what to think. Have a little more white wine, examine the whole thing from the outside, from above and below. It's warm out. Ane and Torben are about to leave. On the stairs I can see an attractive woman who is on her way in. She's wearing zebra leggings and a blue jacket. Behind her come two policemen, they're also on their way in. Before me there's a mass of people that I'll just cast myself into now, just like that, one, two, three.

Iben Mondrup is a trained visual artist from The Royal Danish Academy of Fine Arts who is also the author of four novels, including *Justine*, its sequel, and *Godhavn*.

K erri A. Pierce has published translations from seven different languages in a variety of genres—fiction and non-fiction, novel and short story. Her translation of *The Faster I Walk, The Smaller I Am* by Kjersti A. Skomsvold was a finalist for the International IMPAC Dublin Literary Award.

OPEN LETTER

**OPEN
LETTER**

WWW.OPENLETTERBOOKS.ORG